TAVERN LEAGUE

TAVERN LEAGUE

PORTRAITS OF WISCONSIN BARS by CARL COREY

WISCONSIN HISTORICAL SOCIETY PRESS

Published by the Wisconsin Historical Society Press
Publishers since 1855

Photographs © 2011 by Carl Corey
Text © 2011 by the State Historical Society of Wisconsin

wisconsinhistory.org

Printed in Wisconsin
Designed by Percolator

15 14 13 12 11 1 2 3 4 5

Library of Congress Cataloging-in-Publication Data
Corey, Carl.
 Tavern league : portraits of Wisconsin bars / by Carl Corey.
 p. cm.
 Includes index.
 ISBN 978-0-87020-478-4 (cloth : alk. paper) 1. Photography of interiors.
2. Bars (Drinking establishments)—Wisconsin—Pictorial works.
3. Taverns (Inns)—Wisconsin—Pictorial works. I. Title.
 TX950.57.W6C67 2011
 647.95775—dc22
 2011013760

For my mother

ACKNOWLEDGMENTS

THIS PROJECT WOULD NOT HAVE BEEN POSSIBLE without the dedication and commitment of the tavern owner who provides the place for community members to gather and enjoy themselves. To you a heartfelt thanks for allowing me to photograph in your establishment and for the welcoming support you have shown me.

Thank you to Jason Smith at the Wisconsin Academy of Sciences, Arts and Letters, not only for the exposure and support you have provided but also for believing in this project enough to introduce it to the Wisconsin Historical Society Press. To Andy Adams of Flak Photo; Jane Simon, Sheri Castelnuovo, and Stephen Fleischman of the Madison Museum of Contemporary Art; the staff at Blue Sky: Lisa Martel and Todd Tubutis; and also to gallerists/dealers Sherry Leedy, Crista Dix, and Marla Hamburg Kennedy, my deepest appreciation for the venues you have provided, curatorial expertise, and support.

Thank you to Vincent Virga, the extraordinary picture editor and author, and Jim Draeger, historian and author, for your insightful essays; you add so much to this book.

Lastly I would like to thank Kate Thompson, my editor at the Wisconsin Historical Society Press and the champion of this book. Every author should be so lucky.

ABOUT *TAVERN LEAGUE*

THE TAVERN LEAGUE PROJECT portrays a unique and important segment of the Wisconsin community. Throughout history the local tavern or pub has served as a communal gathering place, offering conversation and interaction among neighbors and friends. Bars are also unique micro-communities, offering a sense of belonging to their patrons. Many of these bars are the only public gathering place in the rural communities they serve. These simple taverns offer the individual the valuable opportunity for face-to-face conversation and camaraderie, particularly as people become more physically isolated through the accelerated use of the internet's social networking, mobile texting, Facebook, LinkedIn, gaming, and the rapid fire of email.

It is impossible that the Wisconsin tavern can endure this cultural and electronic bombardment without going through transition. Evidence of this is already becoming visible, as there is an increasing number of small tavern closures and the impersonal mega sports bar becomes more prevalent. This series attempts to document Wisconsin taverns as they are today. Here's to them. Cheers!

—Carl Corey, 2011

THE SPIRIT OF PLACE

by Vincent Virga

WE HUMANS HAVE A SENSE OF PLACE as strong as a salmon braving up-river or a penguin on the long march. We ignore it at our peril: the resulting alienation results in a death of the heart and ever increasing ecological disasters. Milton may insist: "The mind is its own place," but the heart is aligned with Dorothy Gale in the film version of *The Wizard of Oz* when she declares: "There's no place like home!"

As Milton surely knew, home takes many guises in creatures blessed with memory. Every summer when I return to the West of Ireland, my Mayo friends correctly welcome me "home," because after two decades of living in their community I feel intuitively how I have come home in body, mind, and spirit. I also call Manhattan home, where I am a native; and home for me is Washington, D.C., where I research and write my books. And I've yet another home in Dublin's Sandymount, where on my annual migrations I regroup in a dear friend's house. In each of these places I feel a quiet joy. In each I am secure in my sense of self. In each I feel safe in the world, as I do in several generic environments, such as movie theaters, libraries, museums, and local beaneries—places I associate with pleasure and escape from my daily routines.

Like Carl Corey, I am fiercely alert to the spirit of each place, which possesses me via my eyes. Home in wild Mayo is on a peninsula at the base of the sacred Druid mountain Nephin; Lough Conn is on one side of the house and a flowering bog on the other. New York is, well, New York; my landmarks are the neighboring Gramercy Park and the iconic Chrysler building just up Lexington Avenue and on my apartment wall courtesy of Carl. On Capitol Hill I'm in a restored convent and the sidewalks are red brick. And Dublin is an elegant Victorian row house beside the Star of the Sea church, where Bloom goes to a funeral near the start of Joyce's *Ulysses.*

Our ubiquitous sense of place did not have its own genre in the visual arts until relatively recently, when landscape painting became a form of human expression. Our emotive spirit of place, however, made its debut as a backdrop or a view out a window in Italian Renaissance paintings. (Think of Mona Lisa.) It was a time when the temporal world first sought equality with the spiritual one,

a time when human curiosity defied religious doctrine, a time of immense change in our relationship with the world. It is a time made manifest in the notebook drawings of Leonardo da Vinci, where his studies of place, of the human body and its gestures, and of flowing water become a spiritual experience.

It took several centuries for artists to catch up with him and invent landscape painting. Following his lead, the masters strove to transcend documentation by focusing on form and balance, a technique the Greeks perfected in their pursuit of beauty to instill the breath of life into their art. Somehow it works. We humans respond to the beauty of form with suspension of disbelief and we surrender to the artist's vision, the artist's particular spirit of place.

Carl Corey's camera lens is a charmed circle. Once we enter its domain, he works his end upon our senses, and with his subjects we all stand spell-stopped. Commonplace words for generic environments, such as *tavern* or *bar,* suffer a sea change into something rich and strange before our eyes. The simple words are translated into complex visual metaphors for a type of nest we create for ourselves, nests as sturdy and lovely as those built by swallows, in which our fledgling souls can mingle and find security in the vast, astounding world we all inhabit together.

Carl's fascination with the beauty and form of man-made environments, especially the details of indigenous architecture, offer endless delight and encourage us to share his feeling response to what he sees and takes into his charmed circle with us. I look at the splendor of these tavern interiors with a childlike wonder. Some would not be out of place in the Emerald City of Oz or as landmarks on the Yellow Brick Road! And they, like Baum's creation, are as American as pizza. They are proud emblems of the American spirit. Like all of us except the American Indians, these glorious structures are transplants to the New World from other, older cultures, and their intricate details and the body language of their inhabitants call up a reverence for the courage and personalities of our pioneer ancestors found in the great novels of Willa Cather.

Yes, the mighty art of Carl Corey is to be treasured by all of us. The images in this truly marvelous book show me a world all new to me and make me giddy enough to exclaim along with the awestruck child of another magician:

"O wonder!
How many goodly creatures are there here!
How beauteous mankind is! O brave new world
That has such people in it!"

A TOAST TO OLD-TIMER BARS

by Jim Draeger

I DRANK MY FIRST BEER at the Beehive Tavern in Oconto at the much too young age of five. My father's German upbringing was probably the reason that he acquiesced to my request. Alcohol was not viewed as a taboo among Wisconsin's ethnic German population, and, like most of my German friends, I was allowed to sip beer under the watchful eyes of my parents. The Beehive was a family-owned bar run by Ray Stutz, a local stone mason, and his wife, Dot. As in many of these mom-and-pop bars, the owners lived in a back room, and Dot kept the place open during the day while Ray worked his other job. I loved going to the Beehive, which perched at the edge of a bridge one block from our house. The lure of candy and sodas was enough encouragement for me, and if I got bored, I just walked home.

That day, as I sat on a bar stool next to my dad, Ray asked what I wanted. When I insisted that I wanted a beer, he looked to my dad, who nodded. Ray tapped off an inch or two of Oconto beer into a shorty glass. It was my first and last glass of our hometown brew, which went out of business shortly after, following the fate of many small

Wisconsin breweries. The beer tasted horribly bitter to my youthful tongue, but I toughed it out and finished the glass. With that drink I naively entered a brotherhood of bar lovers, although it would be many more years before I gained full membership. Some might judge my father's decision from a moral perspective, but the mystique of beer drinking held little appeal for me for many years to come as a result of that tasting session.

For all of its history, the tavern has balanced on a knife's edge where our deep-seated longing for libation, socialization, and entertainment dance with our culture's needs for moral order, accountability, and moderation. This tension has been a constant factor in the history of Wisconsin taverns and has shaped the tavern as it has evolved over the past century and a half.

The bar in its many guises, from stagecoach inn and neighborhood saloon to speakeasy, cocktail lounge, and sports bar, has been buffeted by the tides of change, tugged this way and that by politics, economics, changing social mores, and competition for leisure time. Indeed, the bar might be one of the most flexible of all cultural

institutions. While churches, schools, museums, and libraries seemingly sit rock hard in the sea of time, the tavern is swept along in the currents of change.

In *Tavern League,* Carl Corey freezes fleeting moments of Wisconsin's tavern history as it bobs among the tides and eddies. This work is important because tavern culture helps define the Wisconsin experience. Since the nineteenth century, when waves of German, Polish, and Irish immigrants landed in Wisconsin and swept aside the temperate reforms of Yankee settlers, Wisconsin has been a tavern state.

As a German descendant immersed in that culture, who came of drinking age in the mid-1970s, I grew to love Wisconsin taverns like those depicted in this book. While my peers headed to college hangouts and discos, a few of my friends and I discovered the joys of what we came to call old-timer bars. We fled from the smoke, noise, and congestion of teen bars for a much different experience at these local neighborhood bars. We came to enjoy what Ernest Hemmingway described as "a clean, well-lighted place"—although we were not always welcomed. Both owners and patrons often gave a cold, brusque reception to a carload of hippies crashing the quiet serenity of their barrooms. We learned that our admission was eased if one of us headed directly to the jukebox and played the first Hank Williams song we could find. Hank populated every old-timer juke box, and the incongruity of the strains of "Your Cheating Heart" against our long hair and outrageous clothes bought us the time we needed to warm up the barkeep and earn a place at the bar.

From that time forward, I have loved these classic bars. As a student at UW–Stevens Point, I sat many times at the rail of the Elbow Room, escaping the congested student bars like Buffy's, Butter's, and the Yacht Club. My downtown favorite, however, was the Ritz Tavern, where the eighty-two-year-old owner, Dominick Slazarski, answered the phone in Polish and served an older, local crowd. Dominick warmed up to us kids, probably because my cute young girlfriend, Cindy, danced with him on Friday and Saturday nights, when the bar hosted concertina bands playing polkas. Soon after I left Point, Dominick passed away and the Ritz closed, another classic bar shuttered and gone forever.

I did not appreciate the uniqueness of Wisconsin's tavern culture until I moved to Tennessee and visited my local tavern, located in a converted fast food restaurant. The harsh overhead florescent lights and chairs bolted to the undersides of Formica tables—while arguably creating a clean, well-lighted place—were the antitheses of what I had come to know as a true Wisconsin tavern. Standing uncomfortably in this corporately conceived environment, I realized that a bar is defined by both the architecture of its space and the culture that inhabits it.

Taverns have been and still are predominantly a family business. Low start-up costs, long hours, and patrons longing for a "home away from home" have all rewarded the mom-and-pop operations, and these neighborhood joints have been a cornerstone of the Wisconsin tavern experience. For much of our history, workers lived in modest dwellings: small houses, apartments, and tenements with little space for gatherings of family and friends. Without family rooms, decks, and patios, Wisconsinites used the tavern as an extension of their own living rooms, a place to socialize with friends, family, and neighbors. Tavern owners responded to this longing for a home away from home by decorating their bars to reflect their interests as well as those of their patrons. Their local flavor became a comfortable attraction to their regular patrons and gave each tavern a particular and unique character. As a result, tavern owners have been staunchly individualistic, resisting attempts to standardize, franchise, and homogenize their spaces.

The personalization of these mom-and-pop bars created the very qualities that endeared them to their loyal patrons. The familiarity of a favorite watering hole cast bar keepers in the role of mother, father, banker, confidant, and social worker for generations of customers. As alcohol

frees inhibitions, personal dramas play out in a public venue, making the bartender a social mediator, providing a check on excess and cultural chaos. Carl's portraits—even those devoid of people—capture the emotional connection of bar owner to patron and patron to place. Through Carl's lens, we find ourselves in the role of patron. We see the owners and their taverns from a perspective that is deeply personal and moving.

After college I became an architectural historian, my research and work experience giving me yet another perspective on Wisconsin's classic taverns. I inevitably began to see them as what my profession calls built environments. The casual patron may not realize the degree to which the tavern is a carefully choreographed space. Honed over decades, its architecture is meant to help control the social interactions that occur there. Every element—the tables and chairs, bar stools and bar counter, rail and back bar—limit the physical interaction of patrons and staff. The bar counter creates a defensible space, separating customer and operator in a manner that secures the safety of proprietor and merchandize from the extremes of overindulgent patrons. Carl captures the impenetrability of that barrier in striking portraits depicting the owner ensconced behind the front bar.

During my time as a patron and observer of old-timer bars, significant changes have occurred in their location, demographics, and use. Many of our taverns' once important social roles have been replaced. Taverns no longer function as a necessary extension of our living rooms. The larger square footage of today's homes and the addition within them of family rooms, home theaters, and other entertainment spaces have created a cultural shift toward staying at home that sociologists describe as cocooning. Tougher drunk driving laws and stiffer regulations have forced bars out of residential neighborhoods, encouraging people to drink at home. The number of bars has constricted sharply since the 1970s, creating a harsh and competitive environment for the remaining old-timer bars.

This makes the work of Carl Corey all the more important. His book is a magical alchemy, mixing the realism of documentary photography with an artistry that is transcendent, capturing a mood, a presence, an impression of the fleeting world of taverns past. His photos frame more than a mere sense of place; we are drawn into their warm, rich color, the drama of their details, and the intimacy of their composition. His artistry is creating photos that pull us both intellectually and emotionally into vignettes comprising a slice of time and place. For me, that is enough to ensure that the love my friends and I have shared of old-timer bars will live on for others to appreciate.

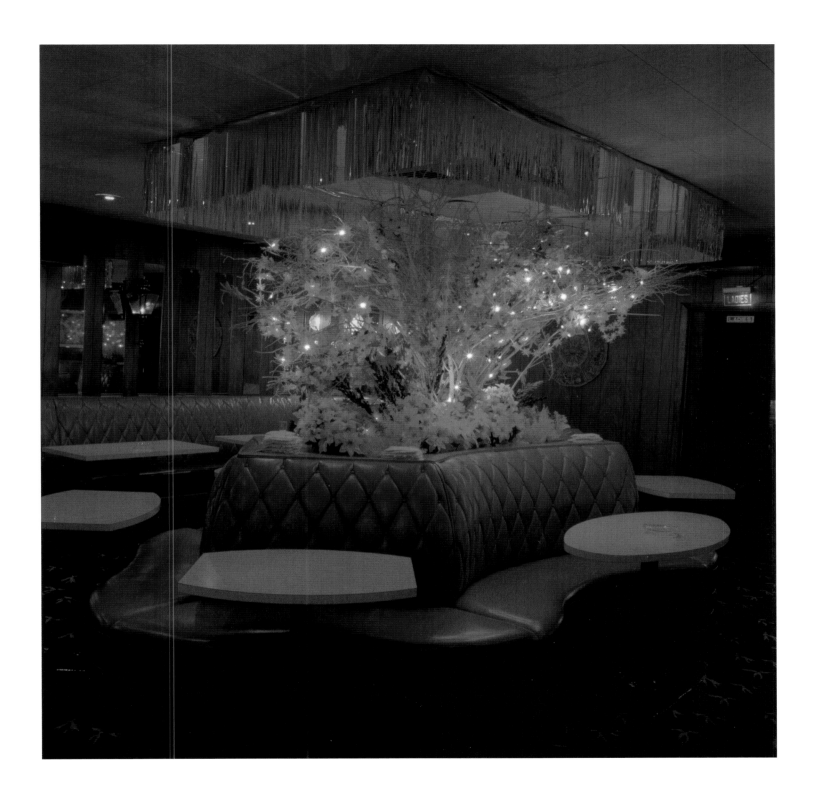

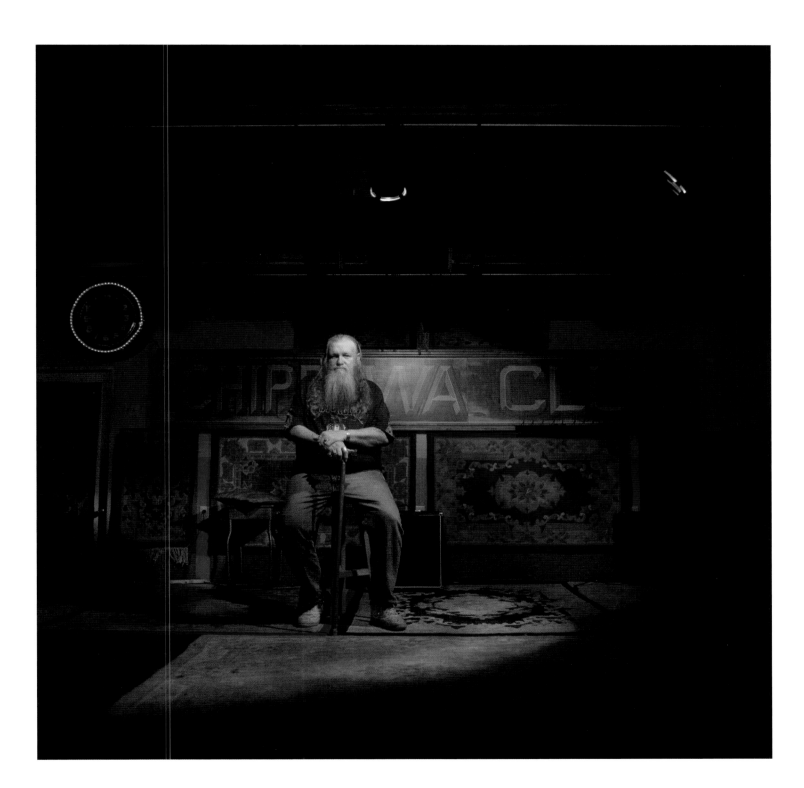

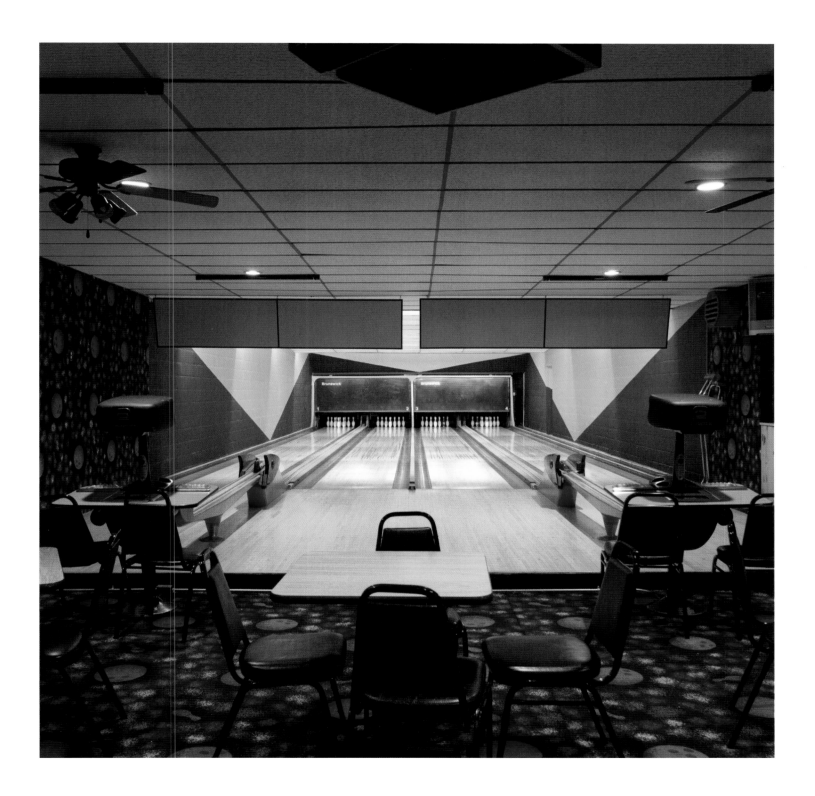

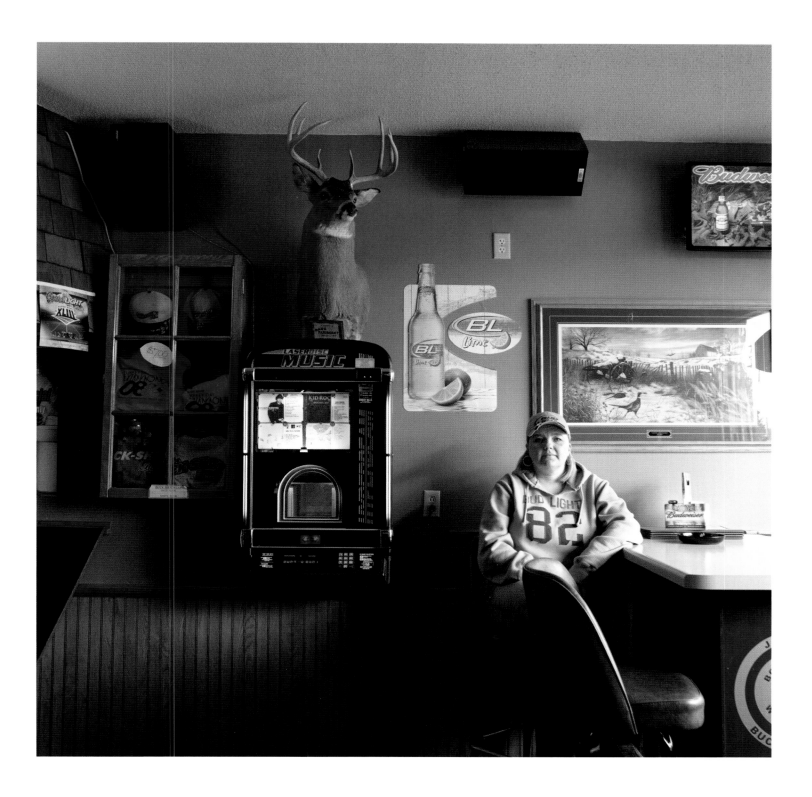

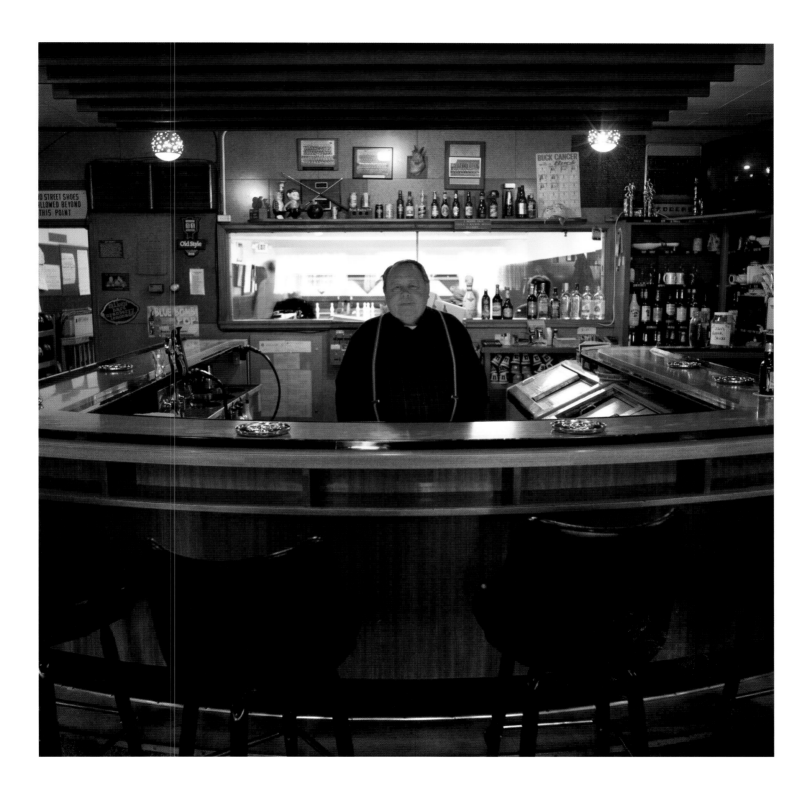

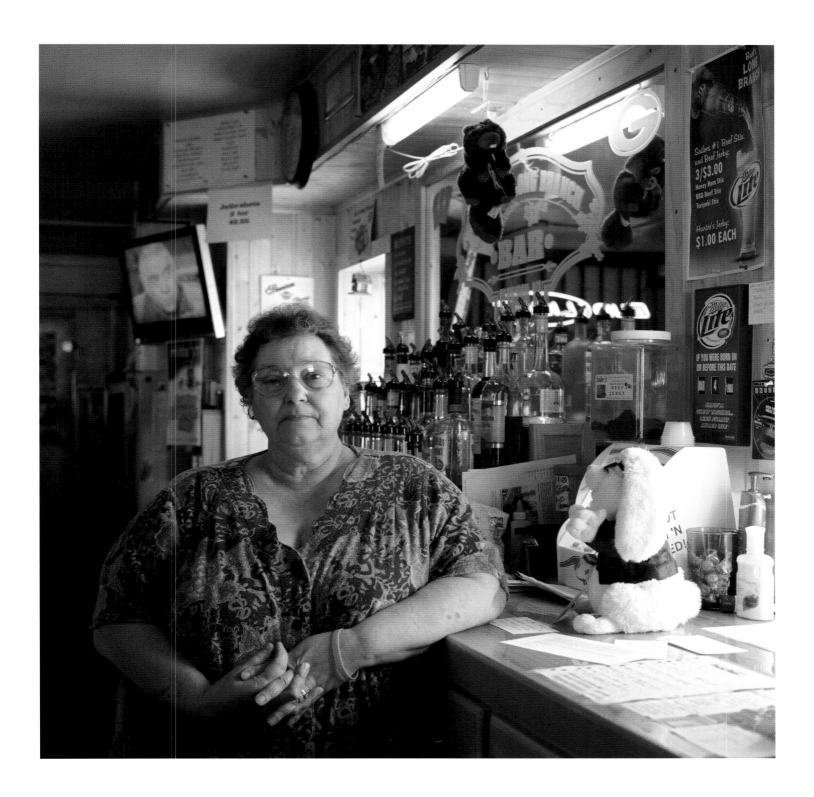

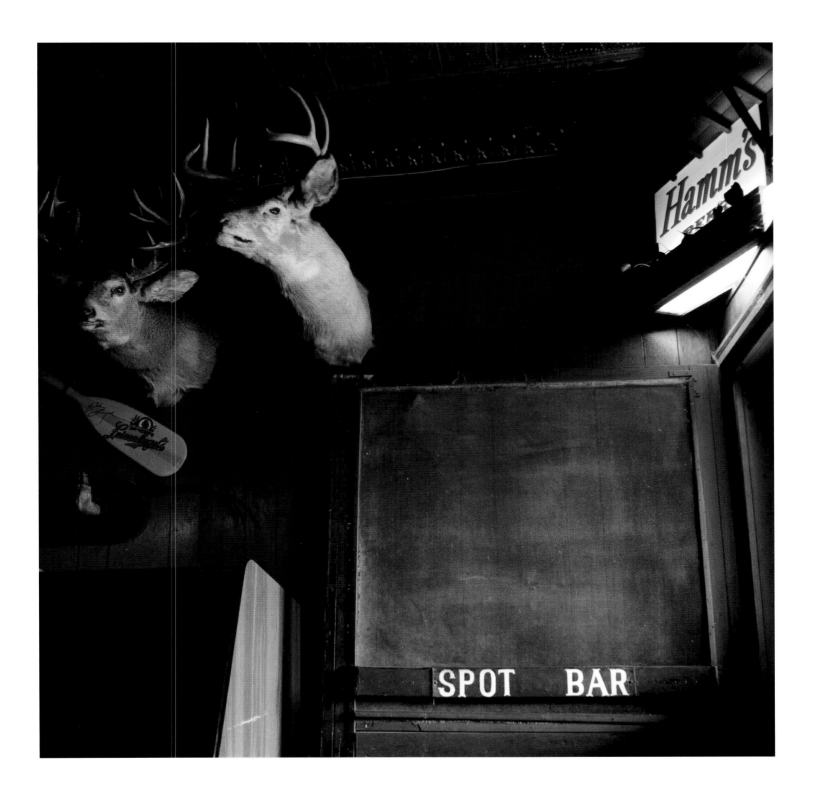

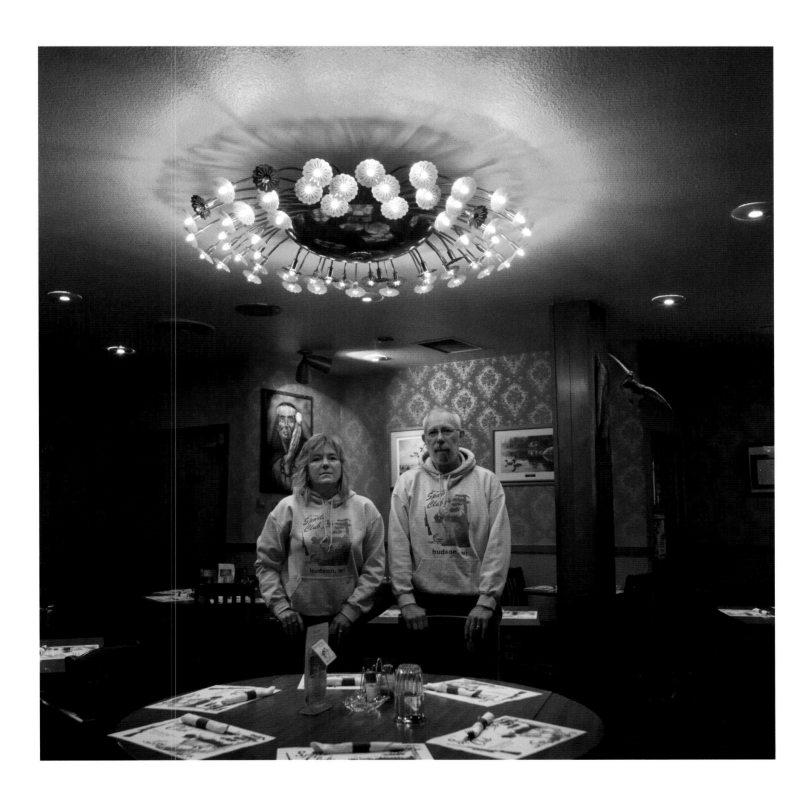

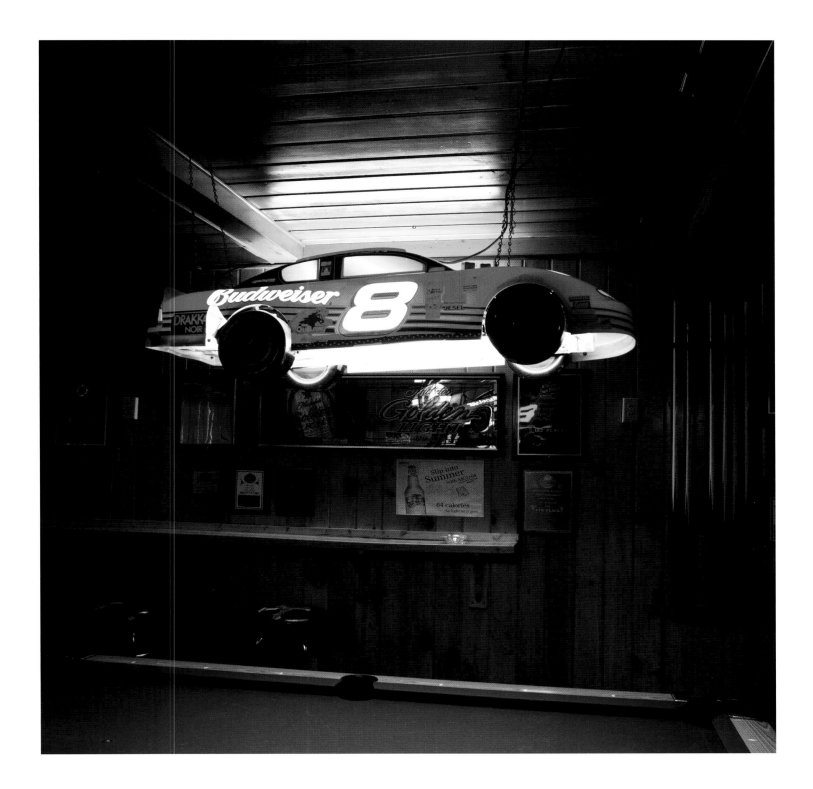

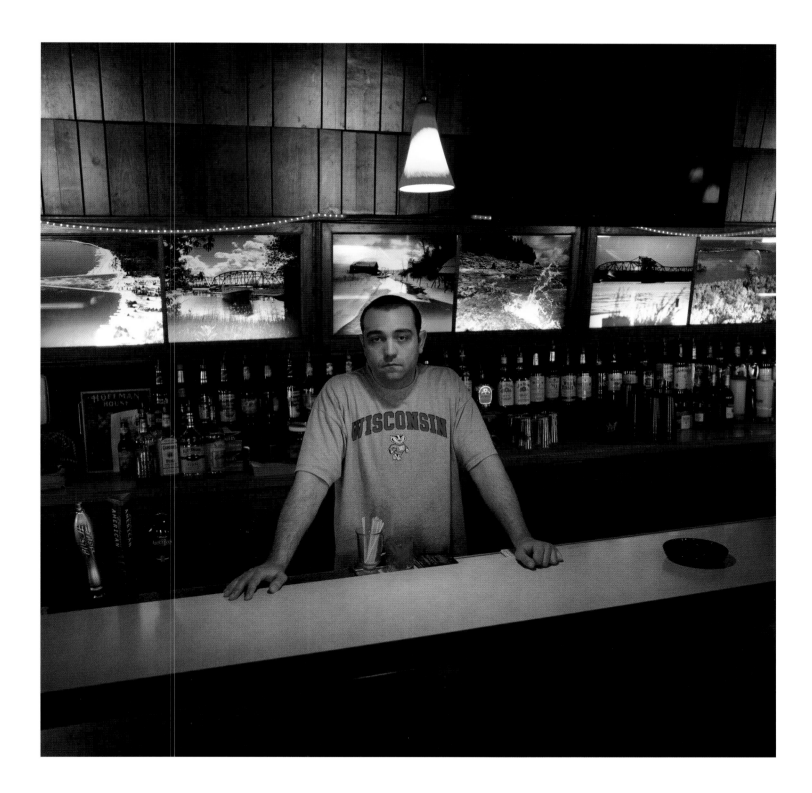

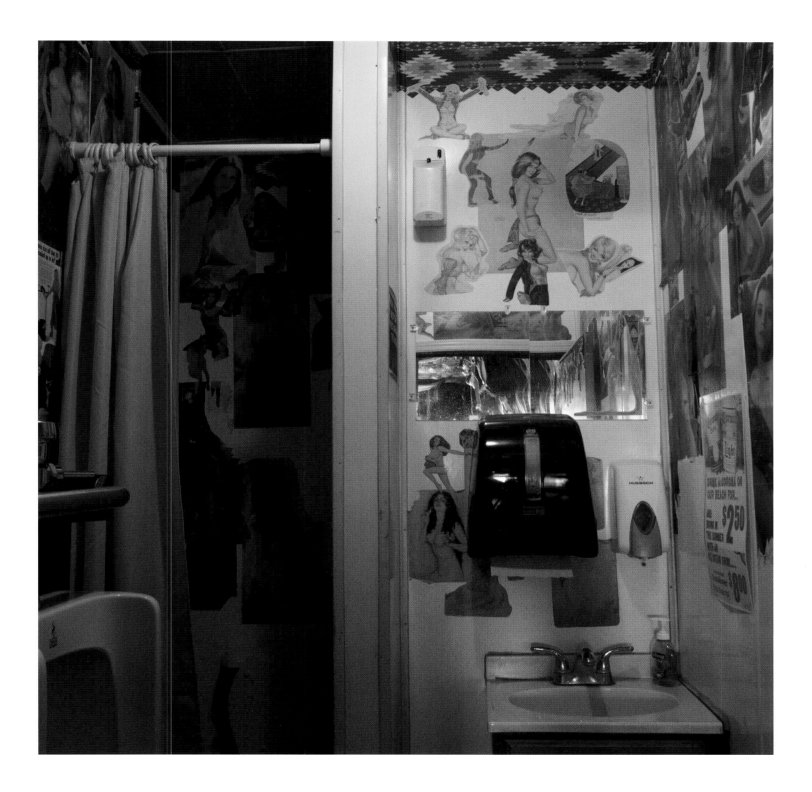

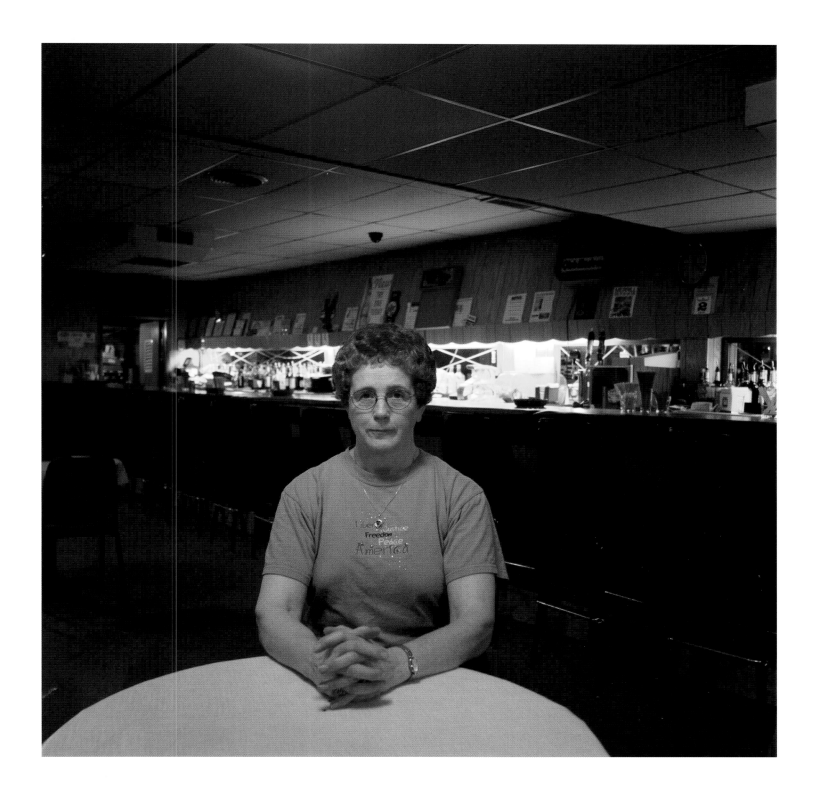

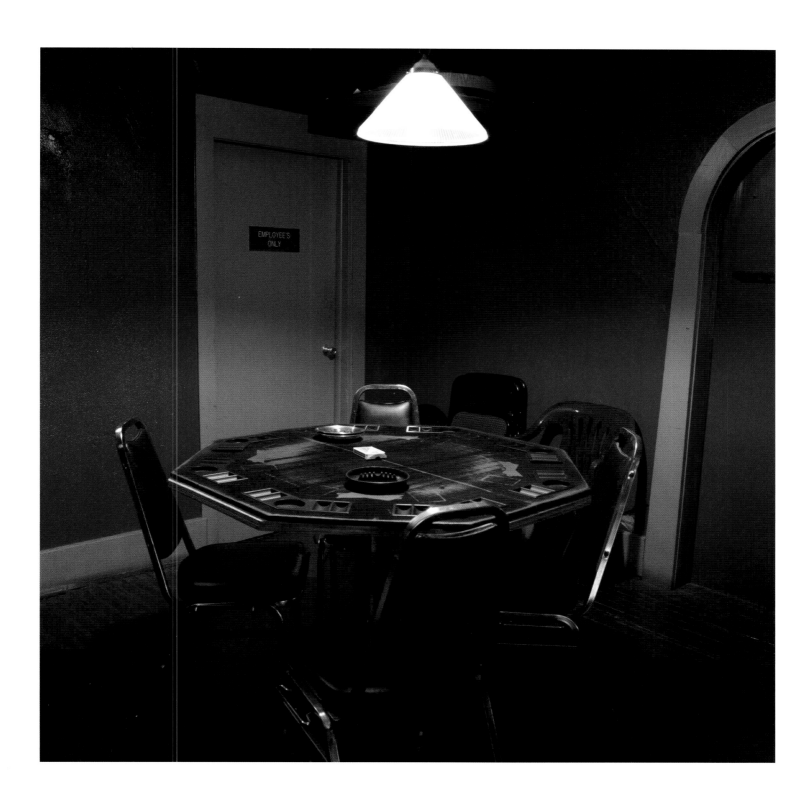

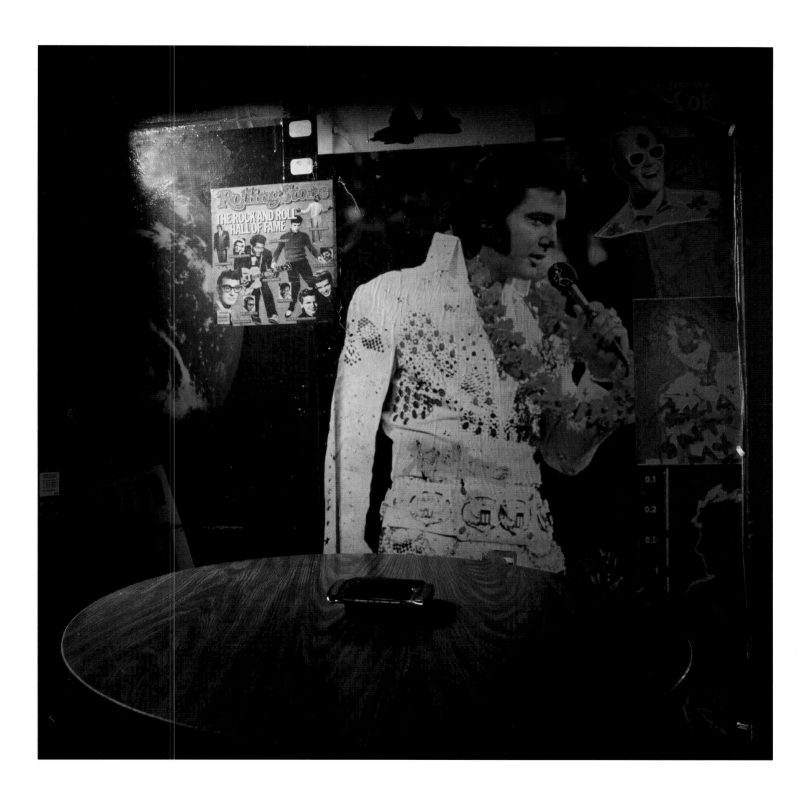

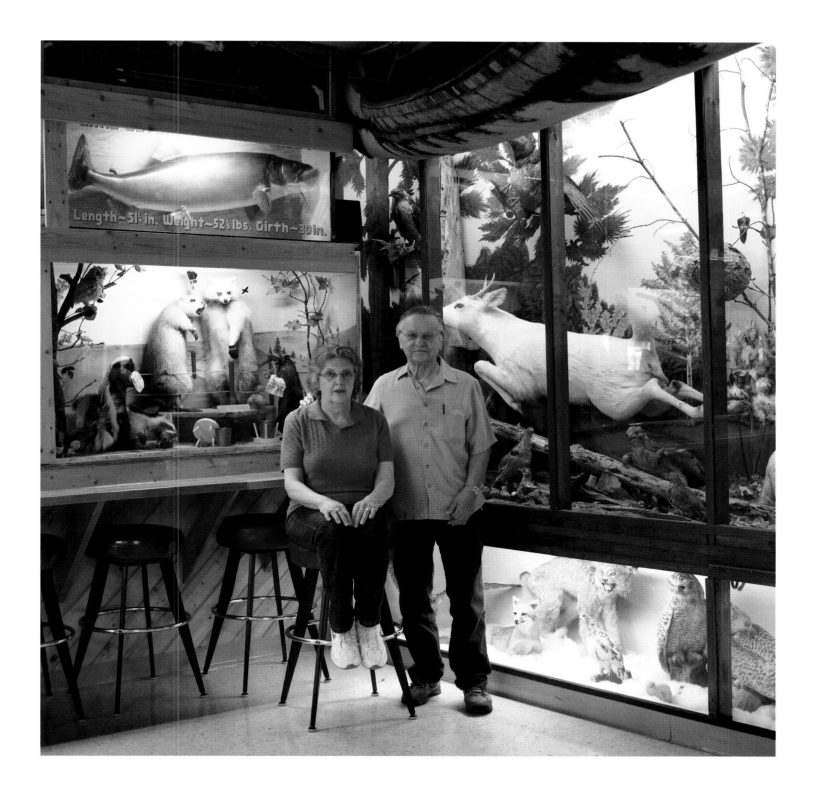

Length~51½ in. Weight~52½ lbs. Girth~30 in.

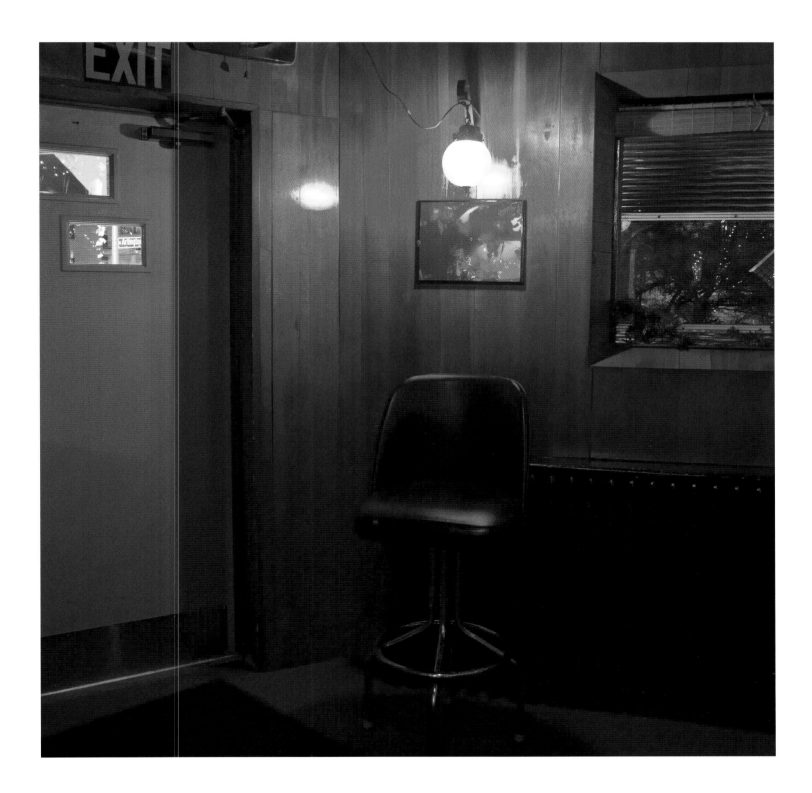

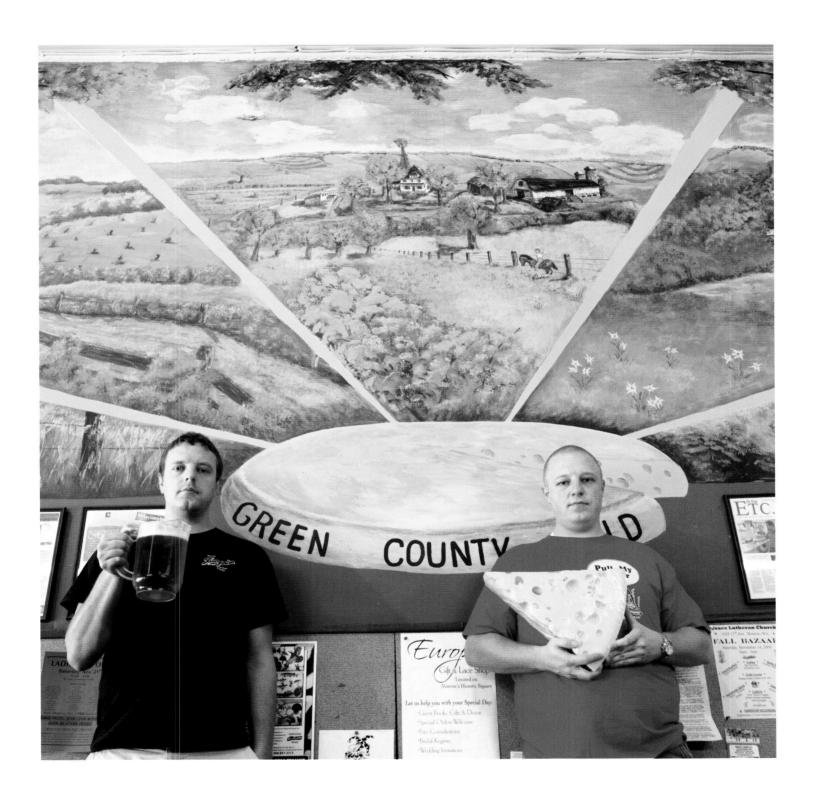

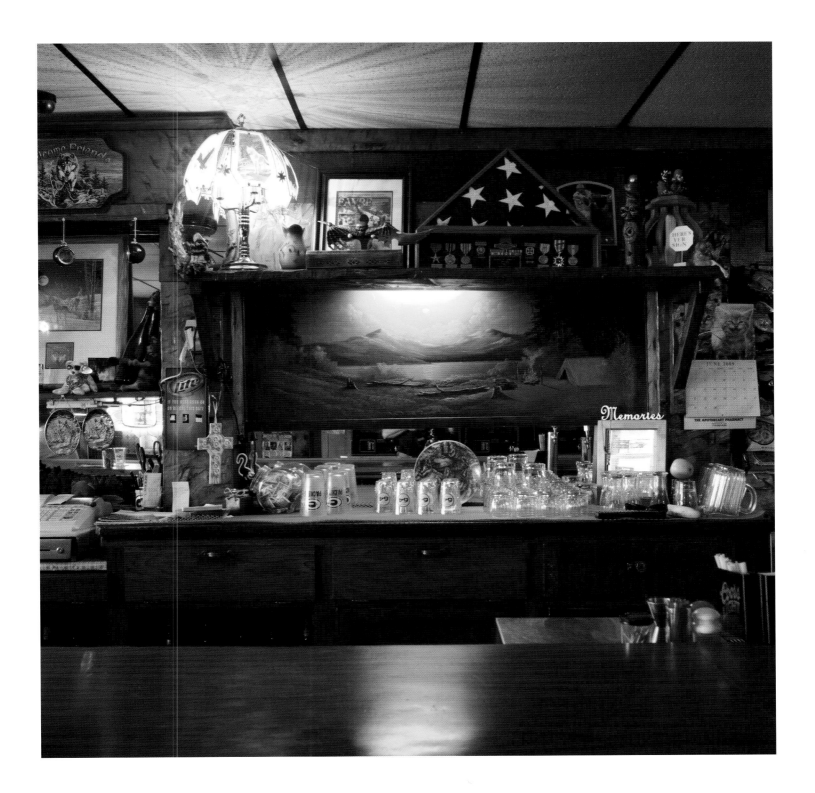

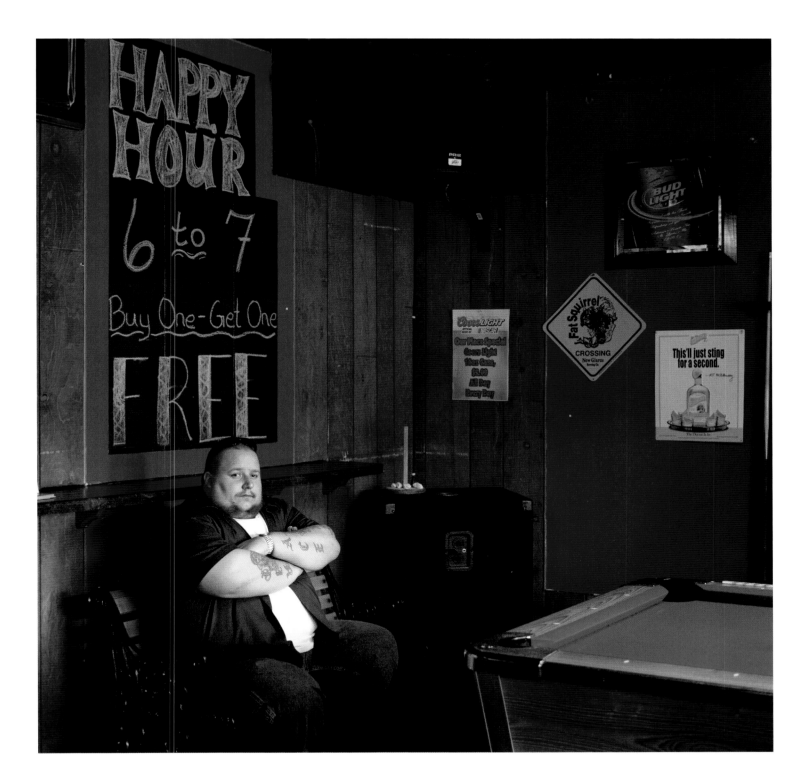

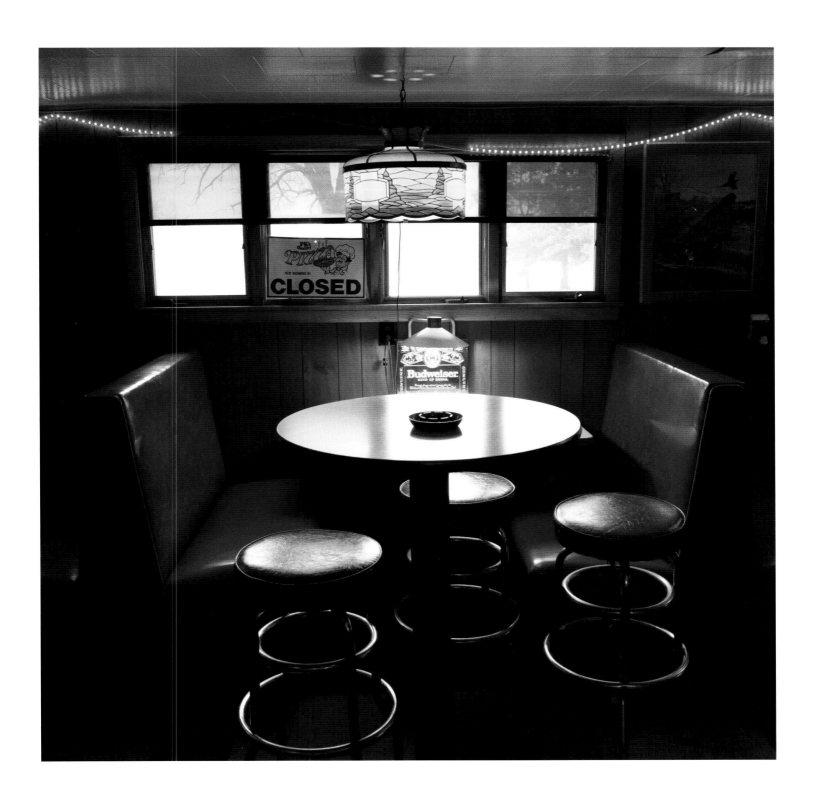

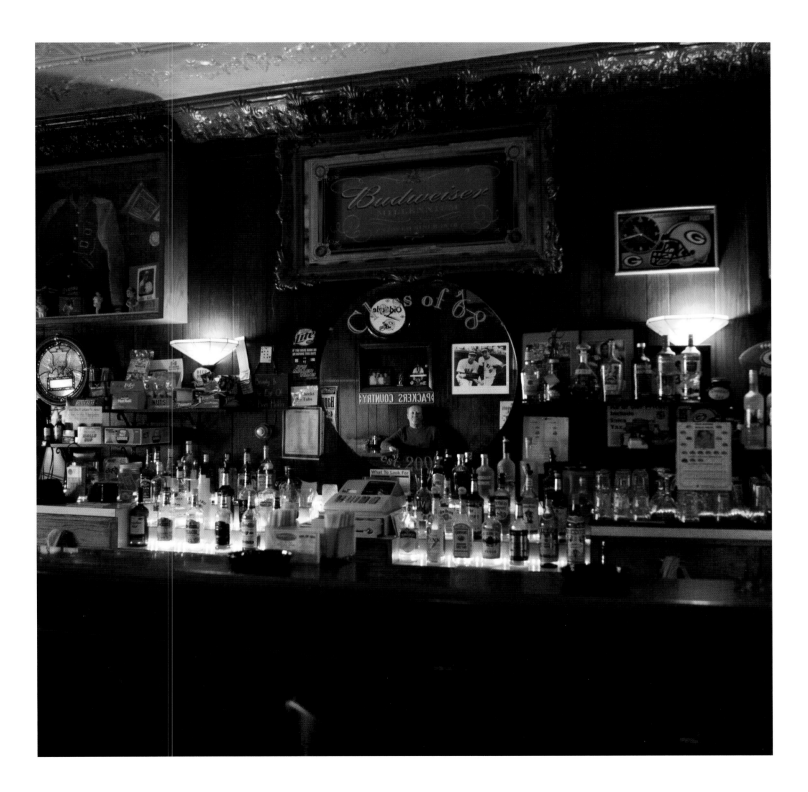

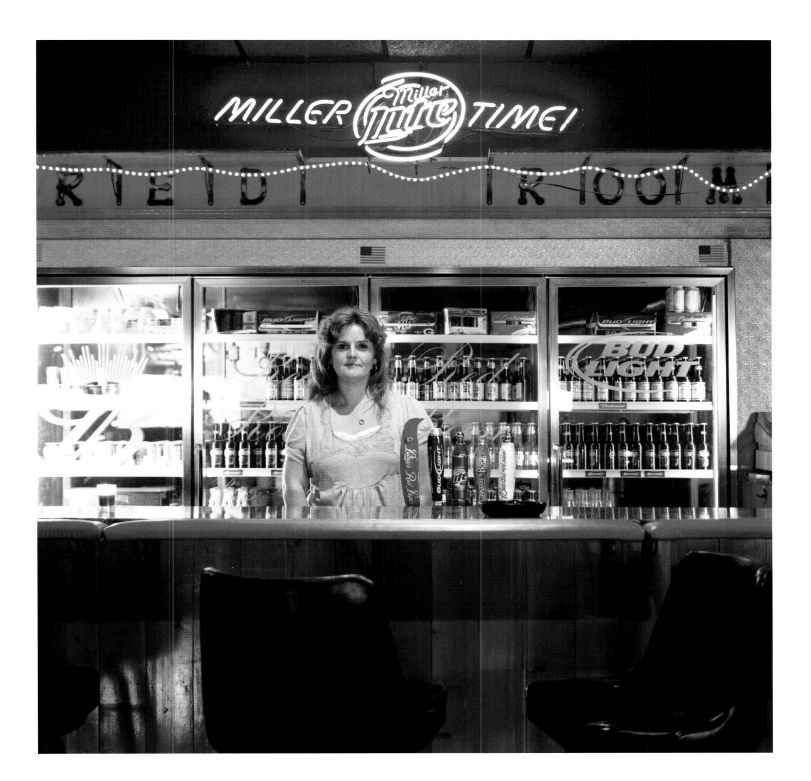

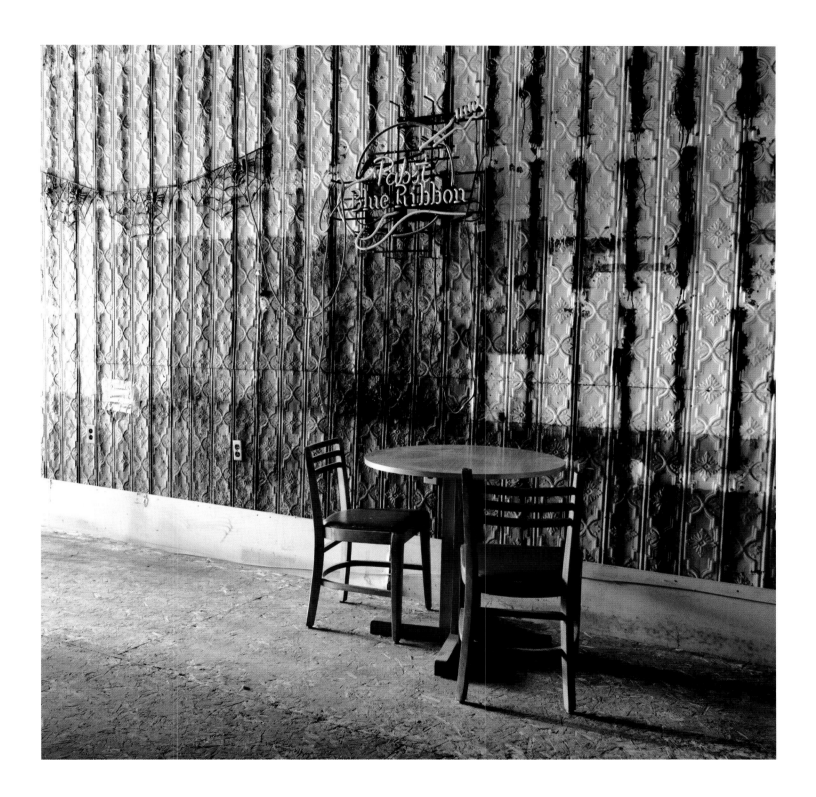

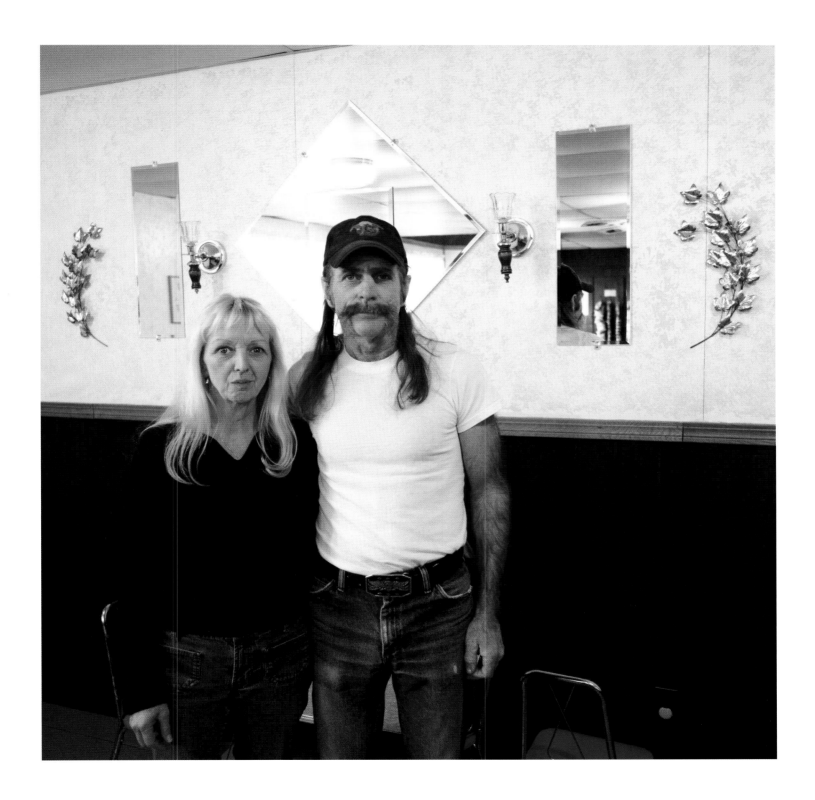

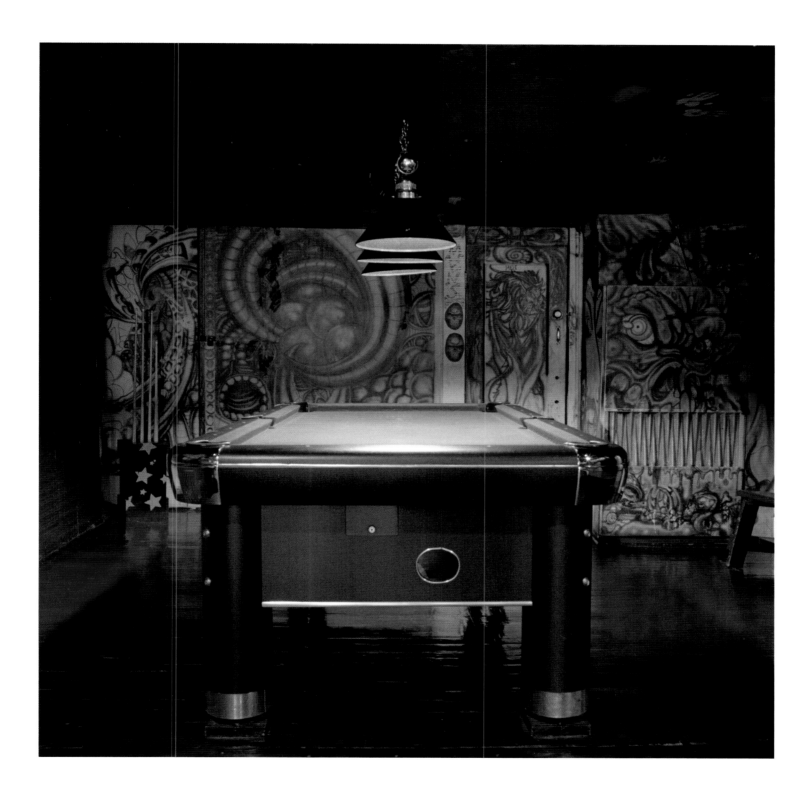

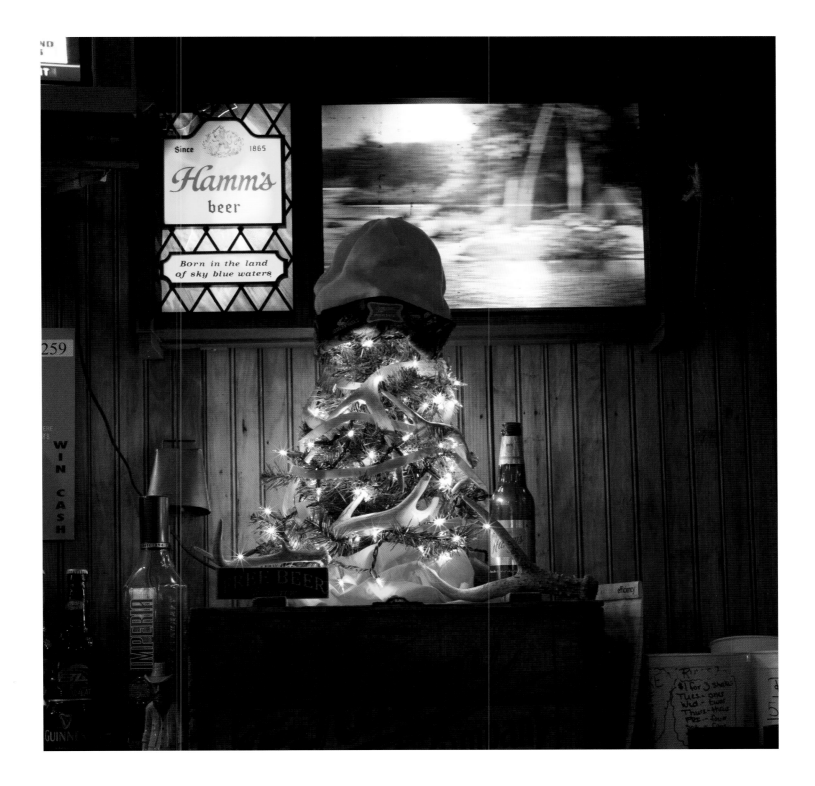

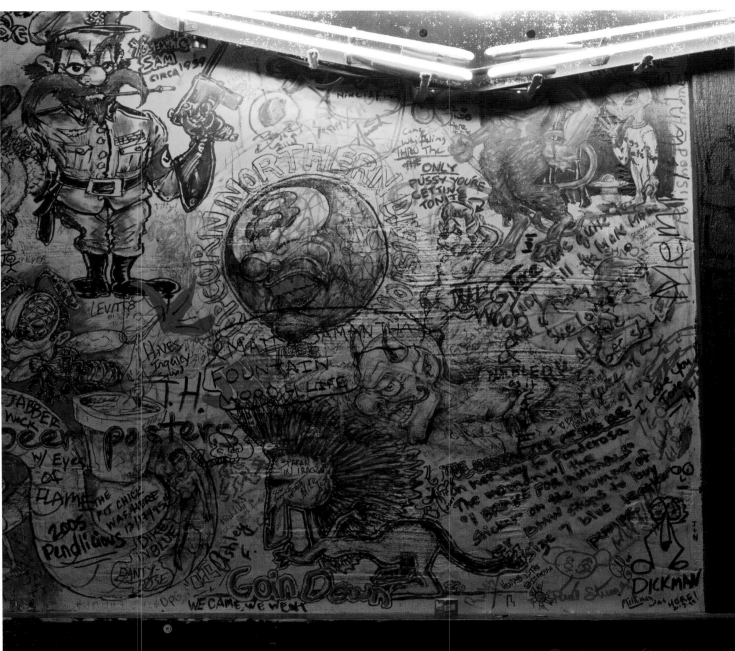

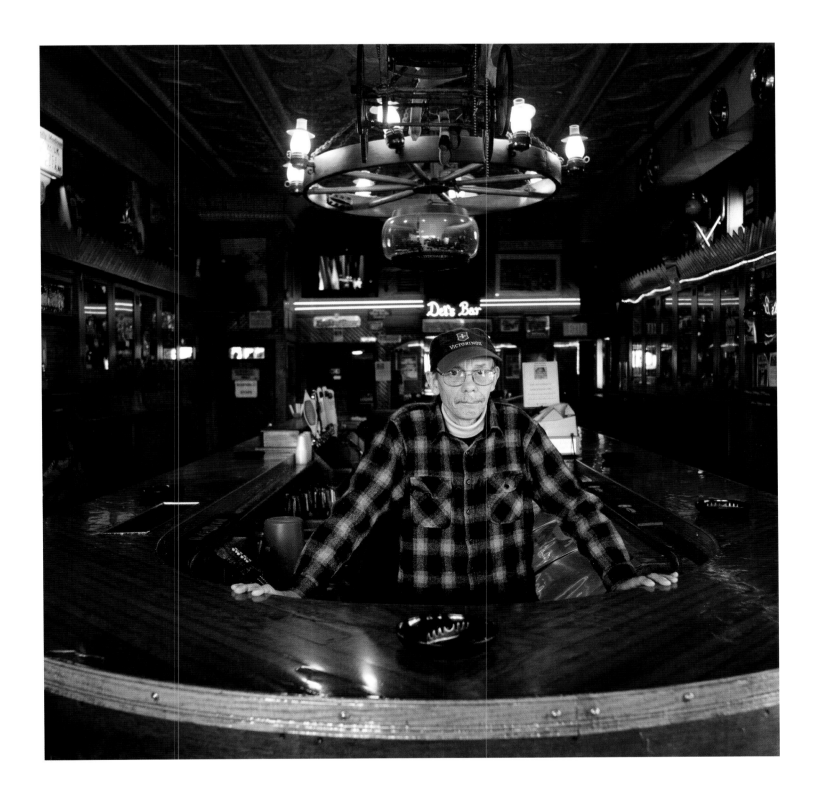

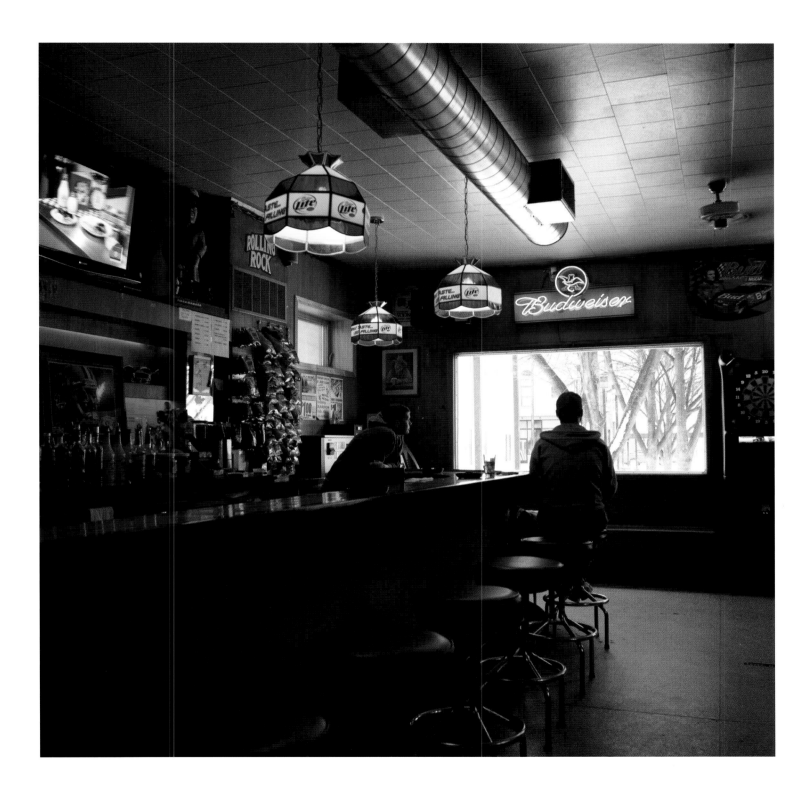

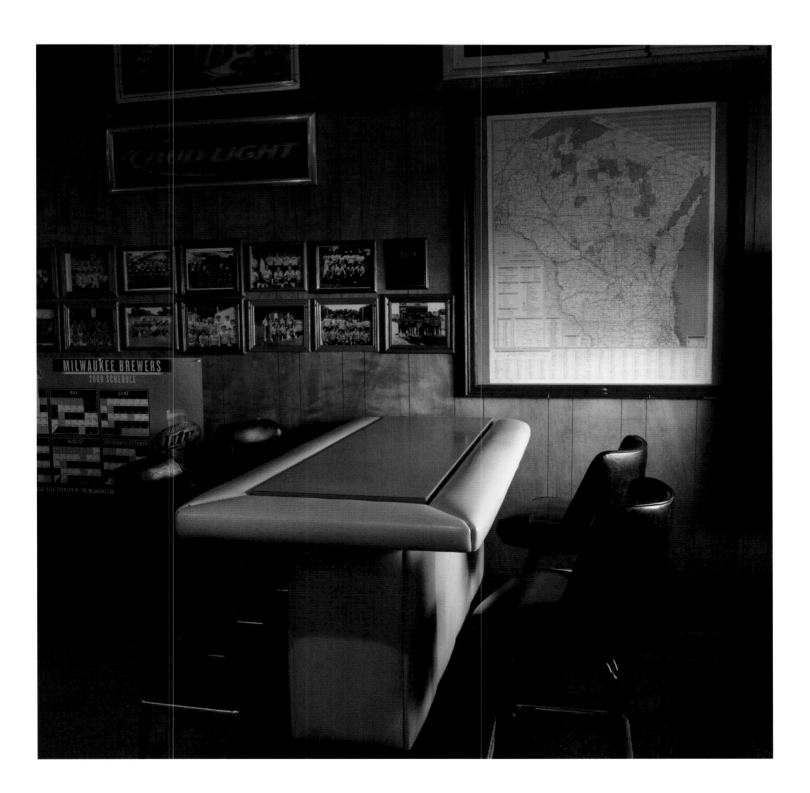

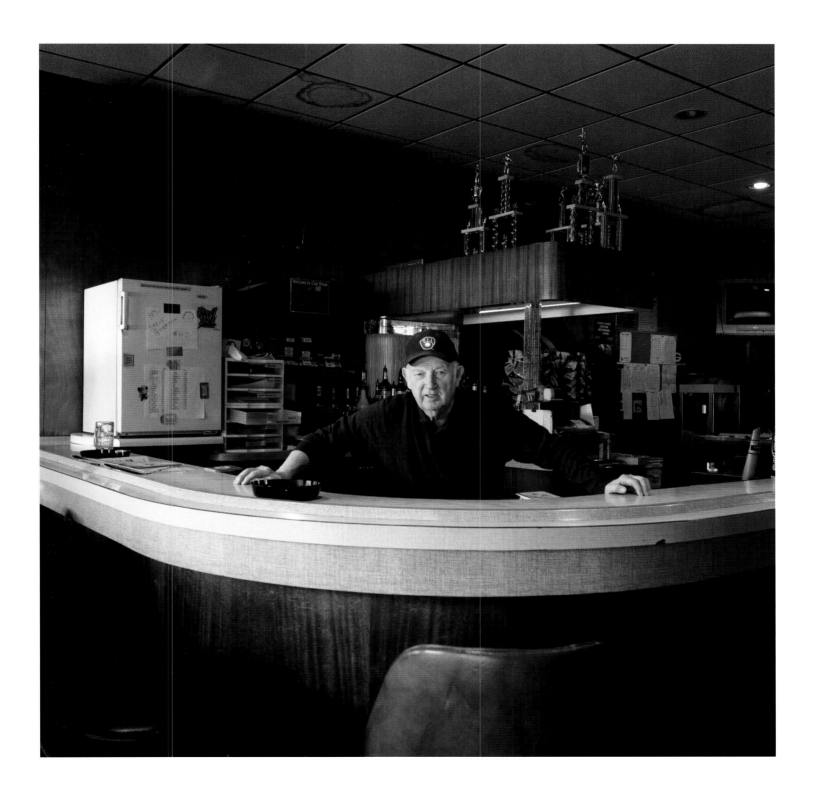

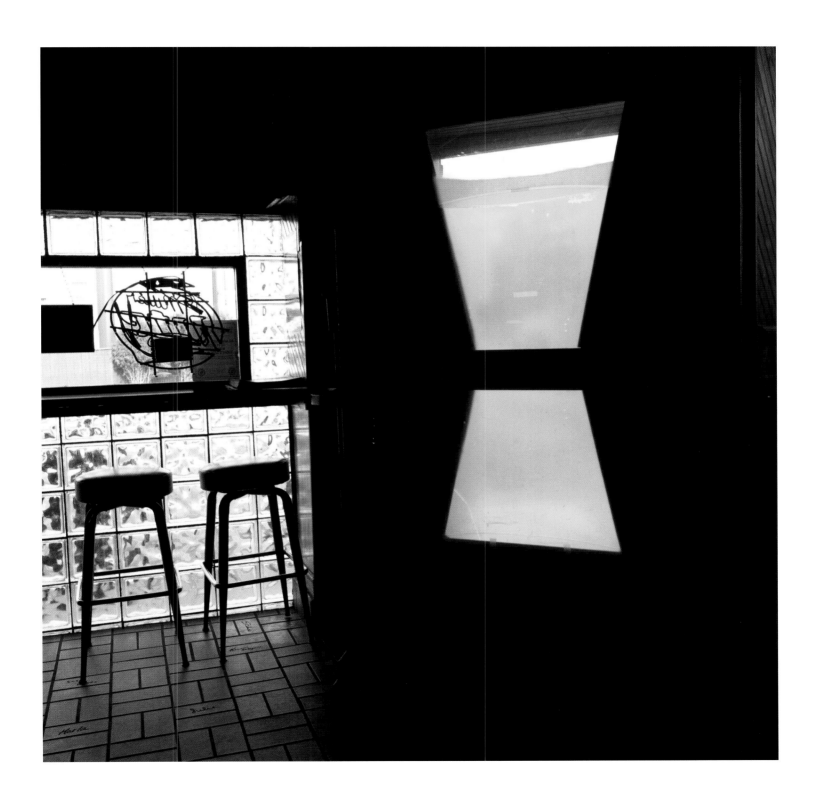

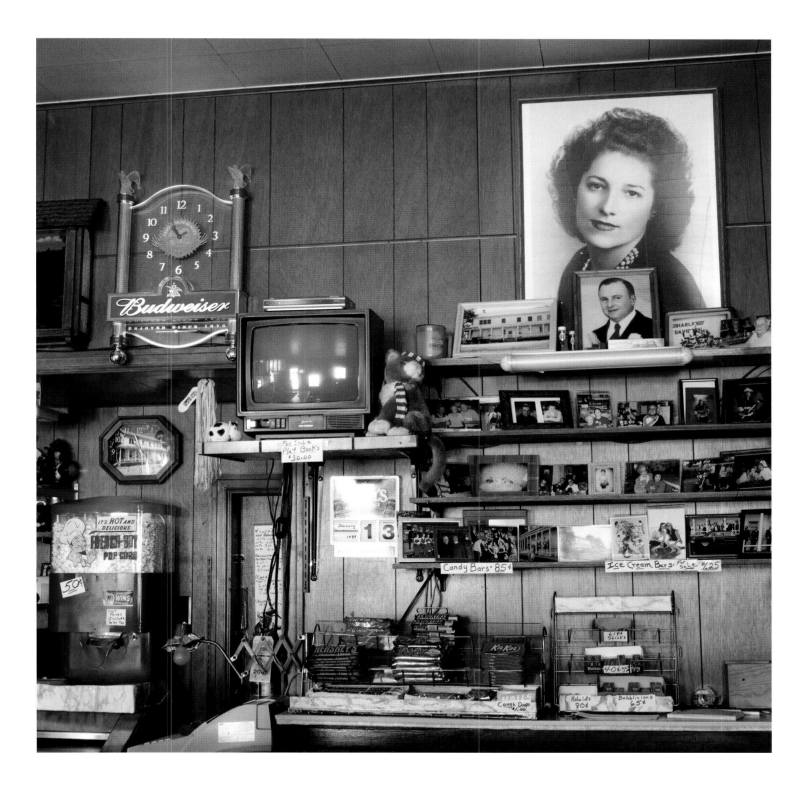

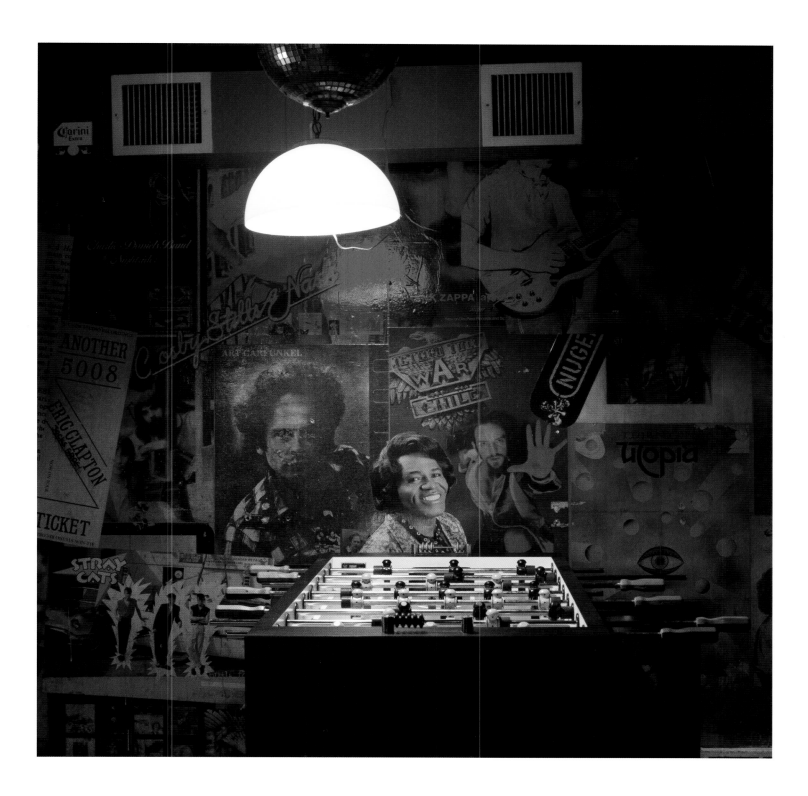

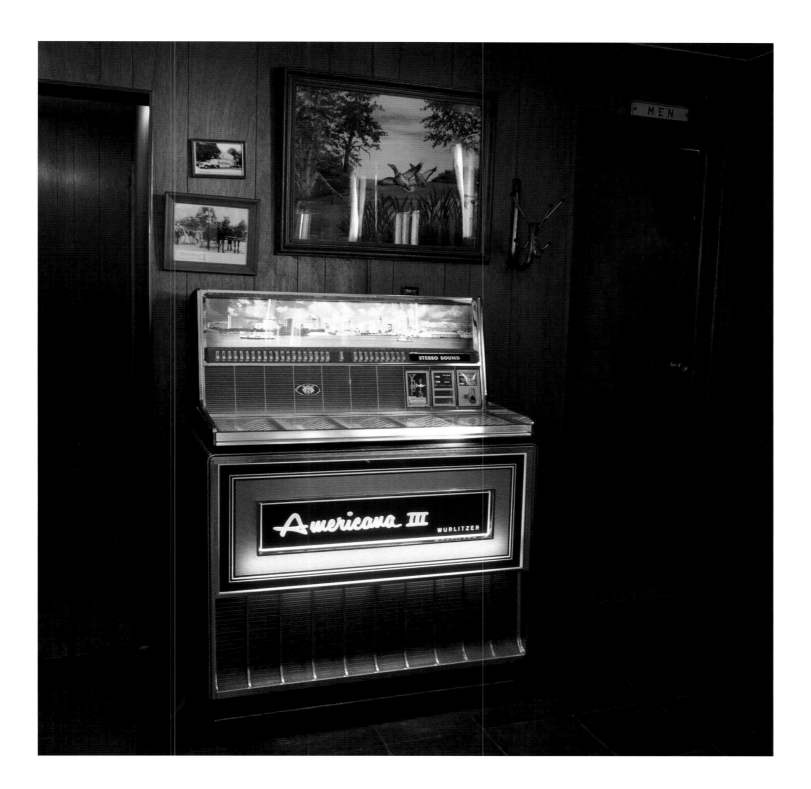

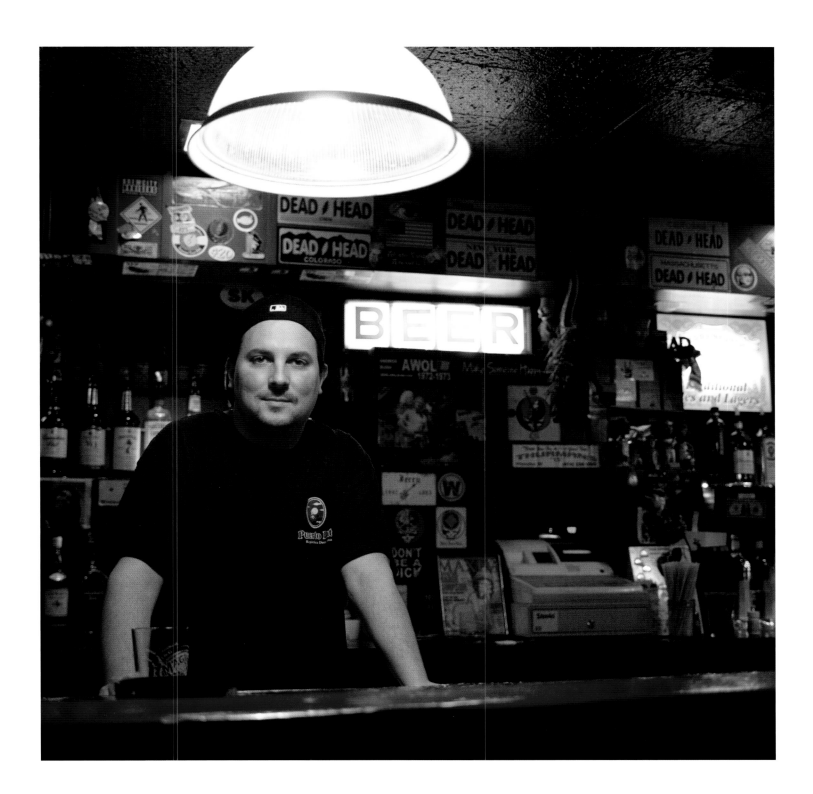

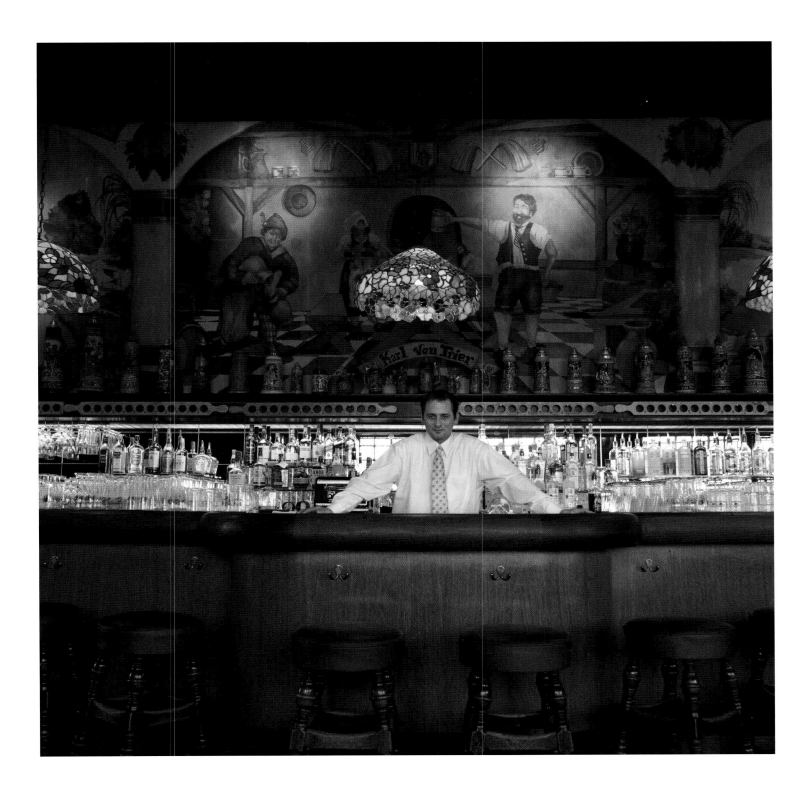

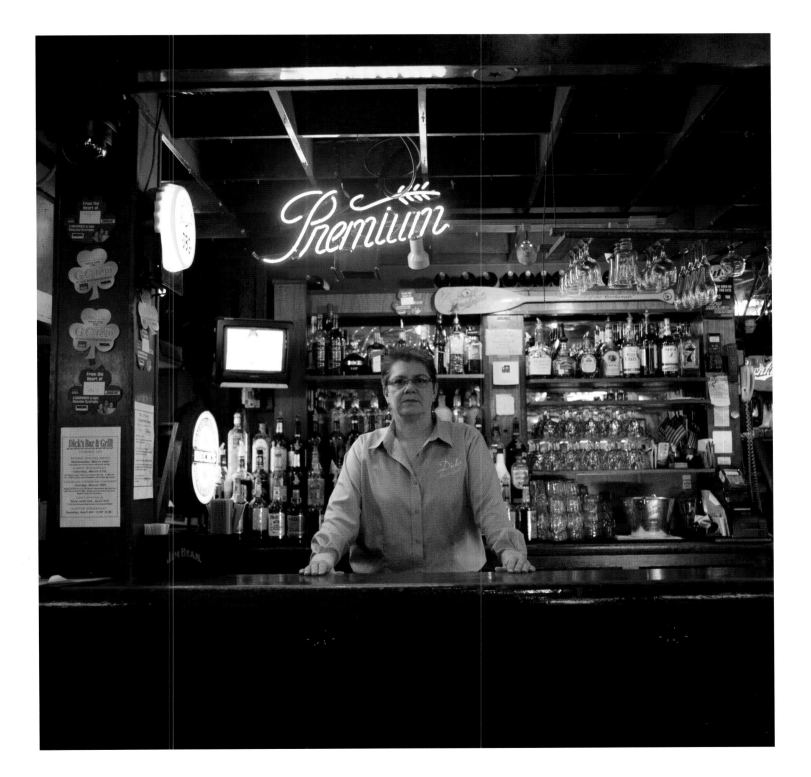

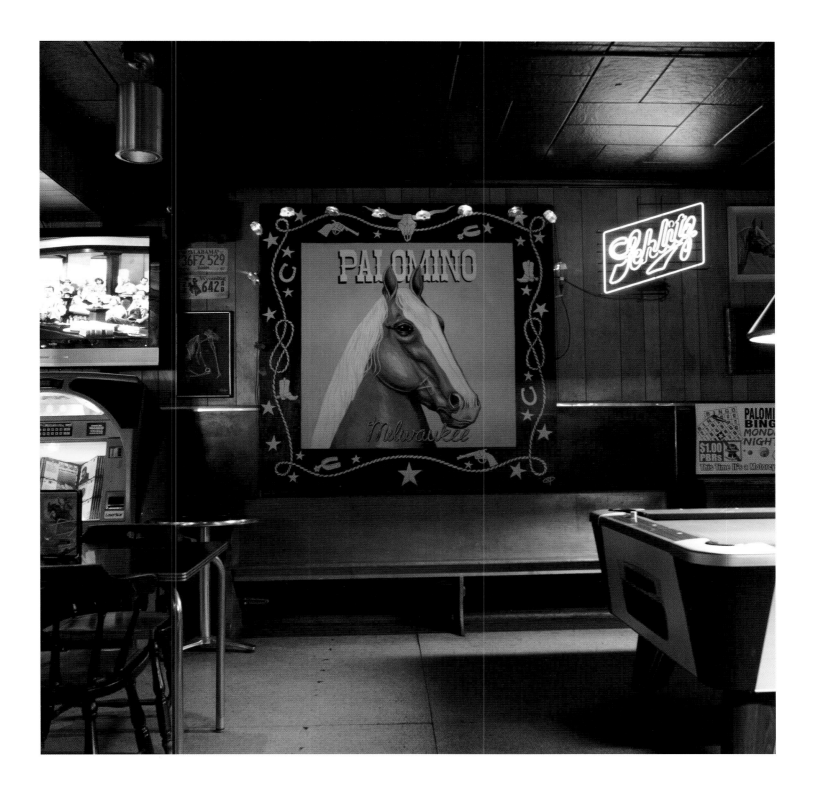

2767 | The Blue Room, Ashland

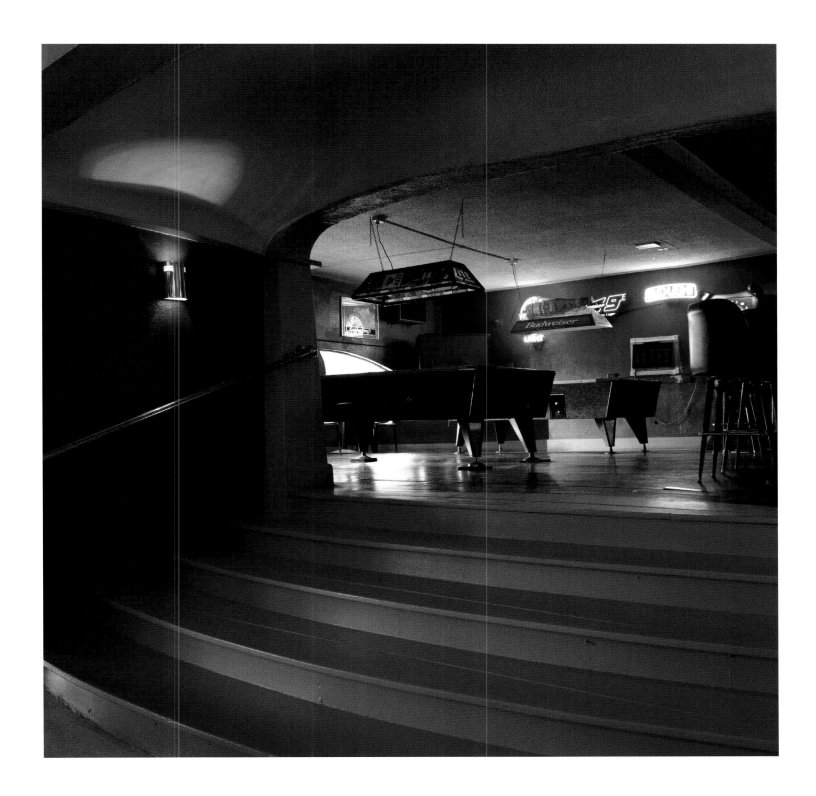

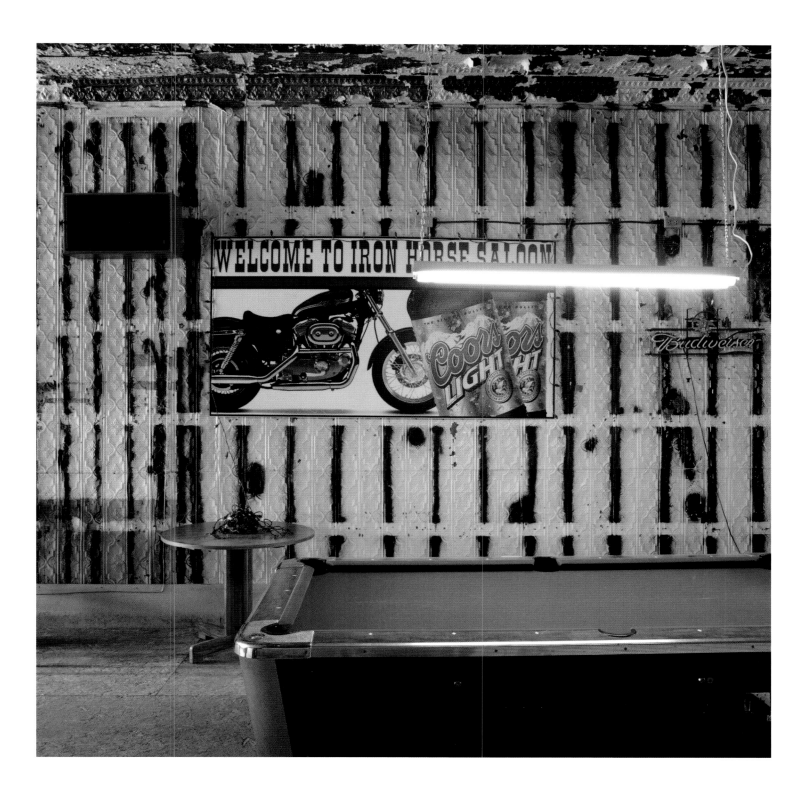

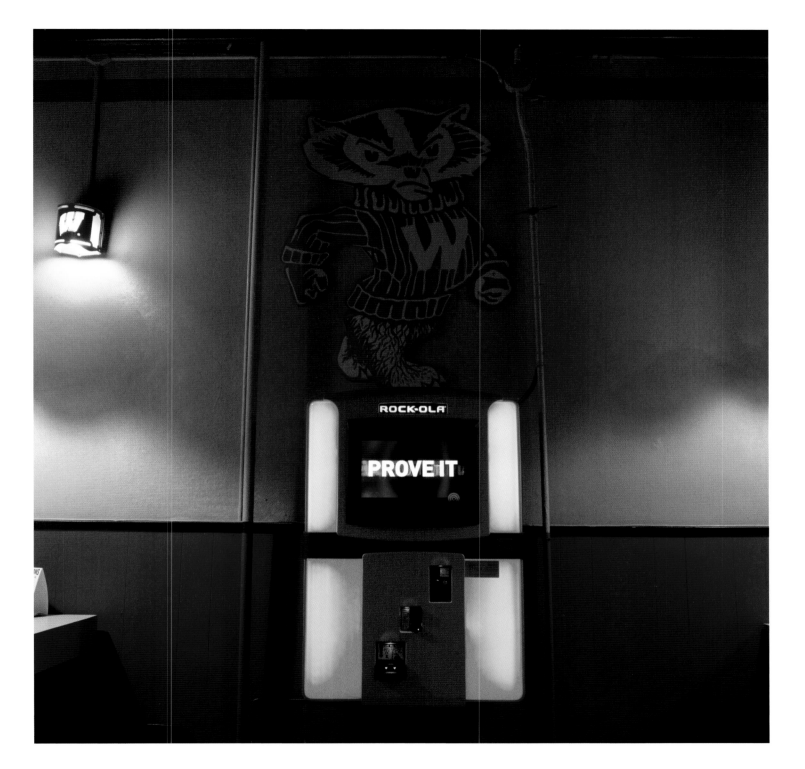

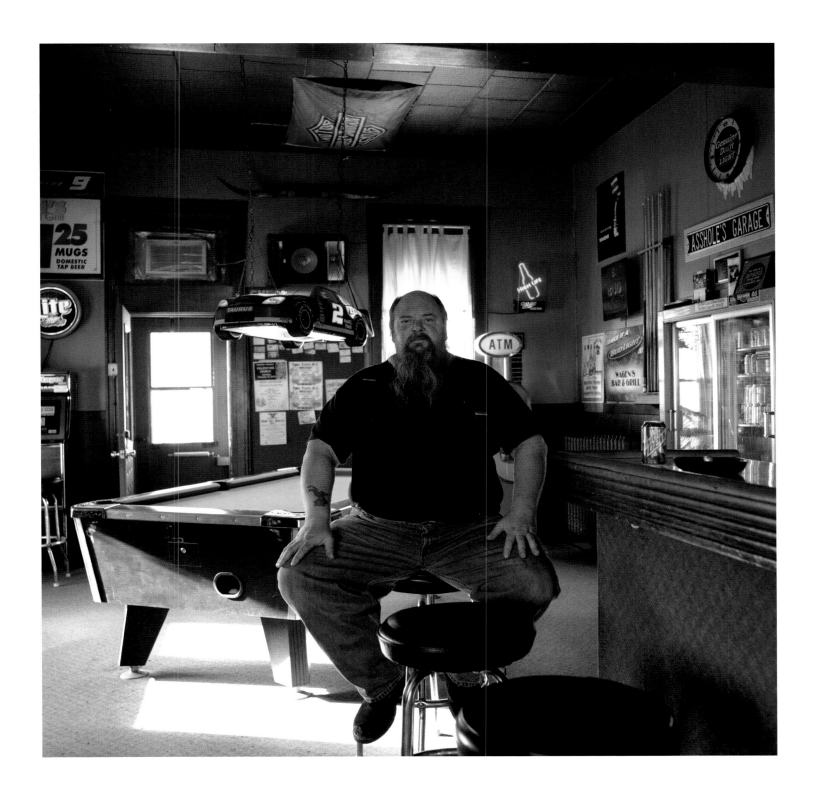

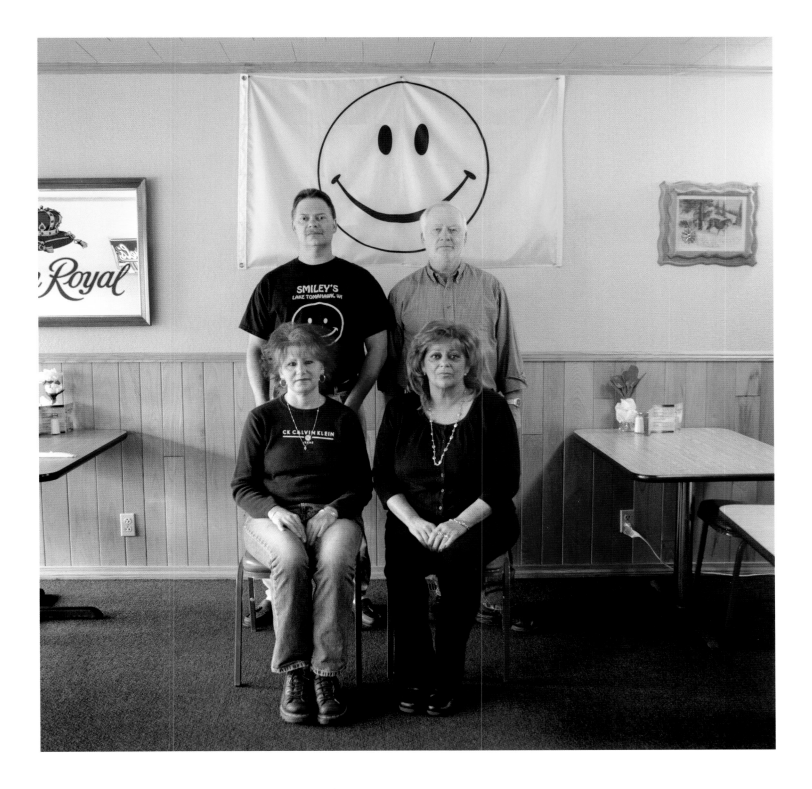

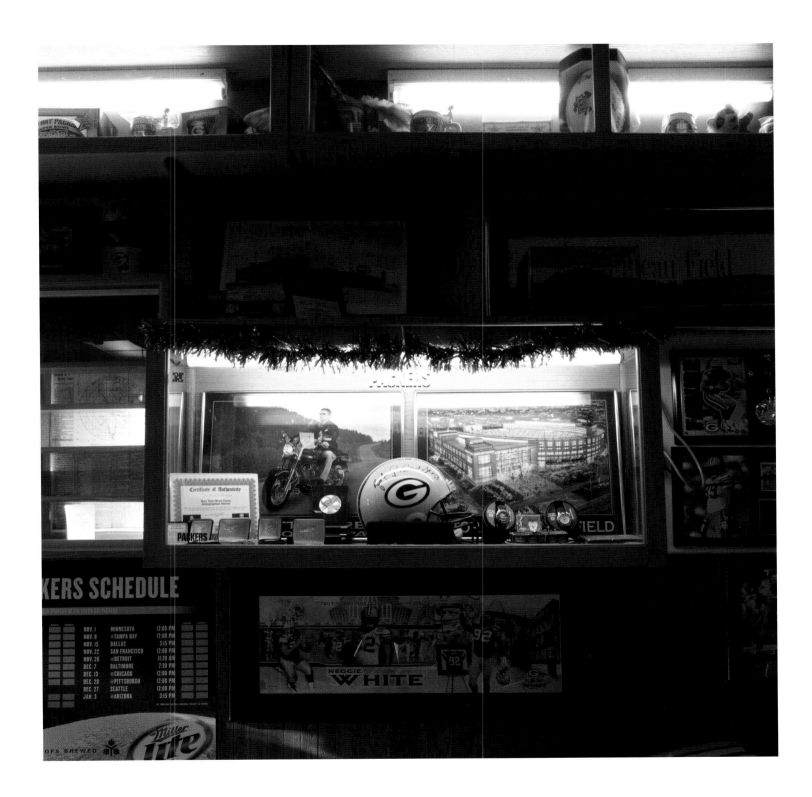

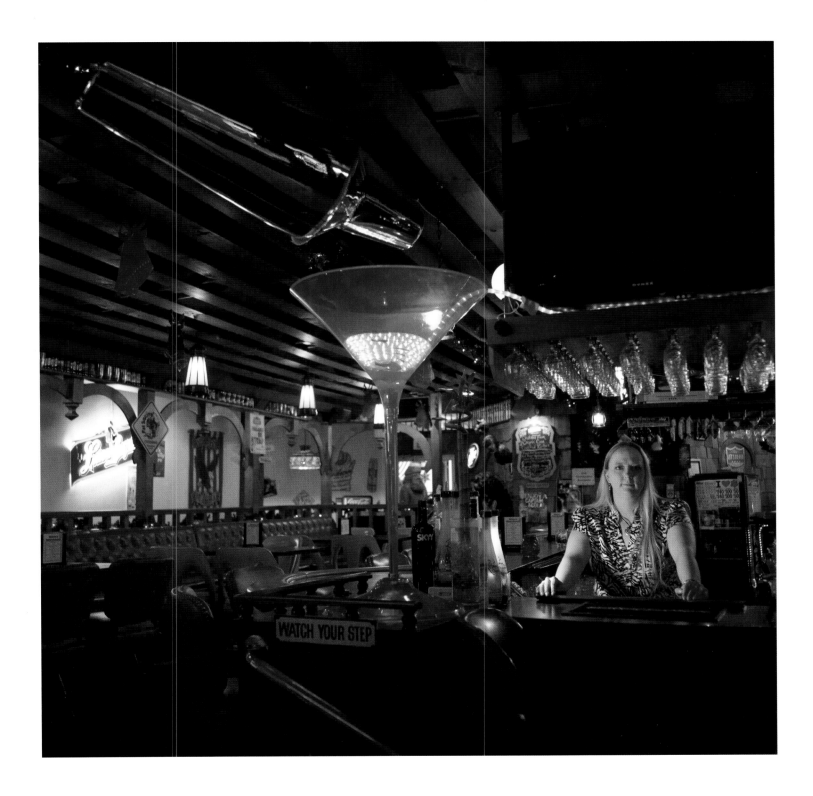

WATCH YOUR STEP

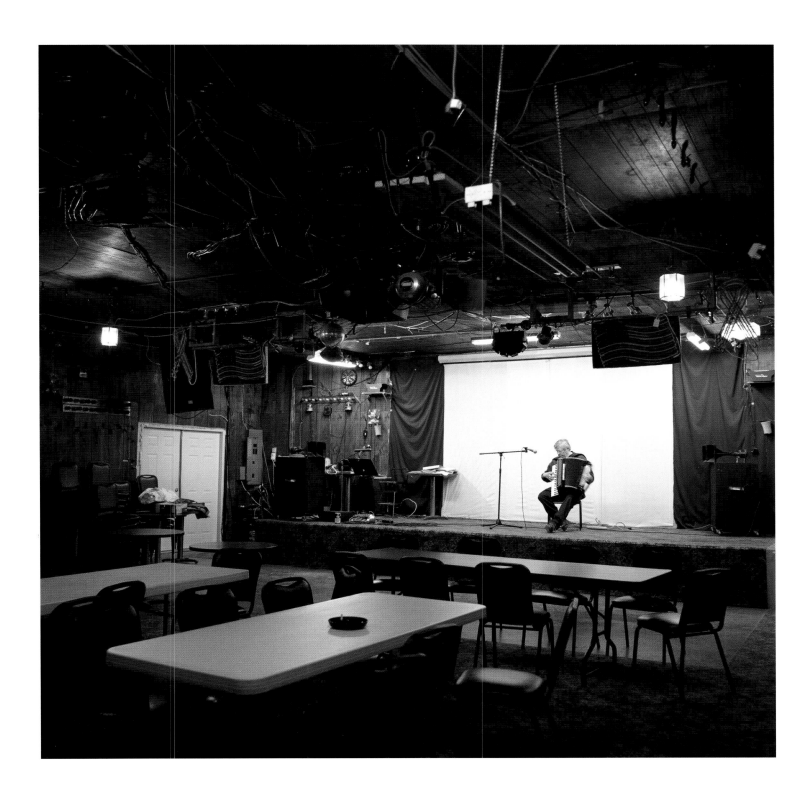

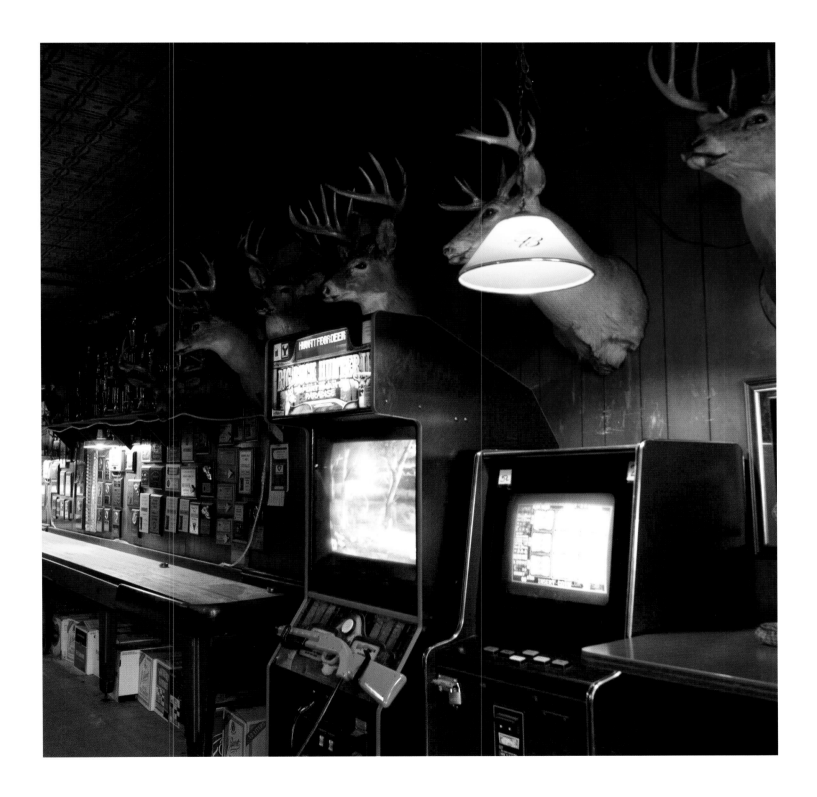

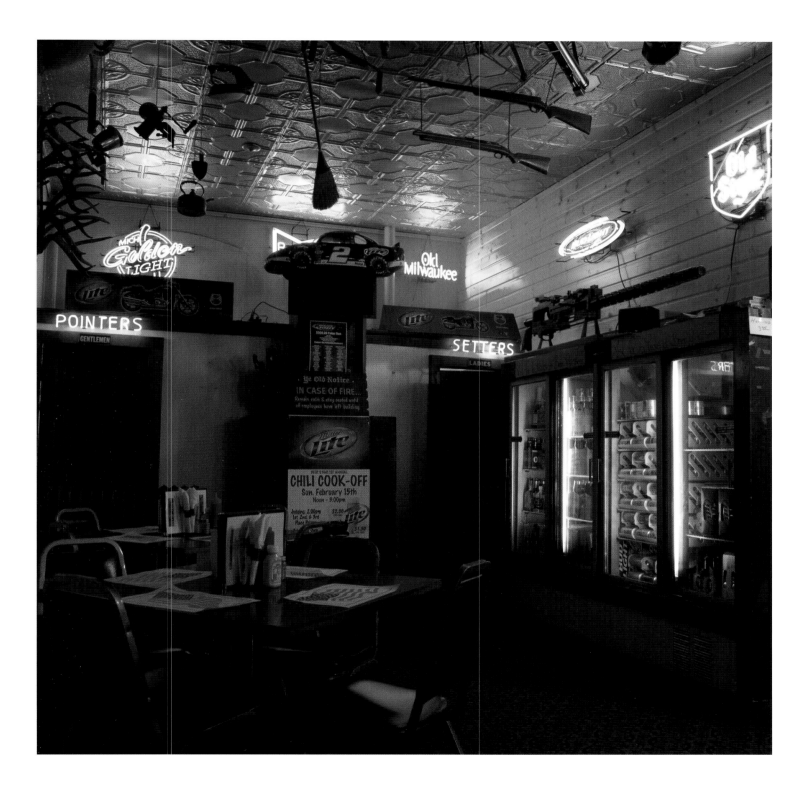

2696 | Ballroom, The Red Room, Sturgeon Bay

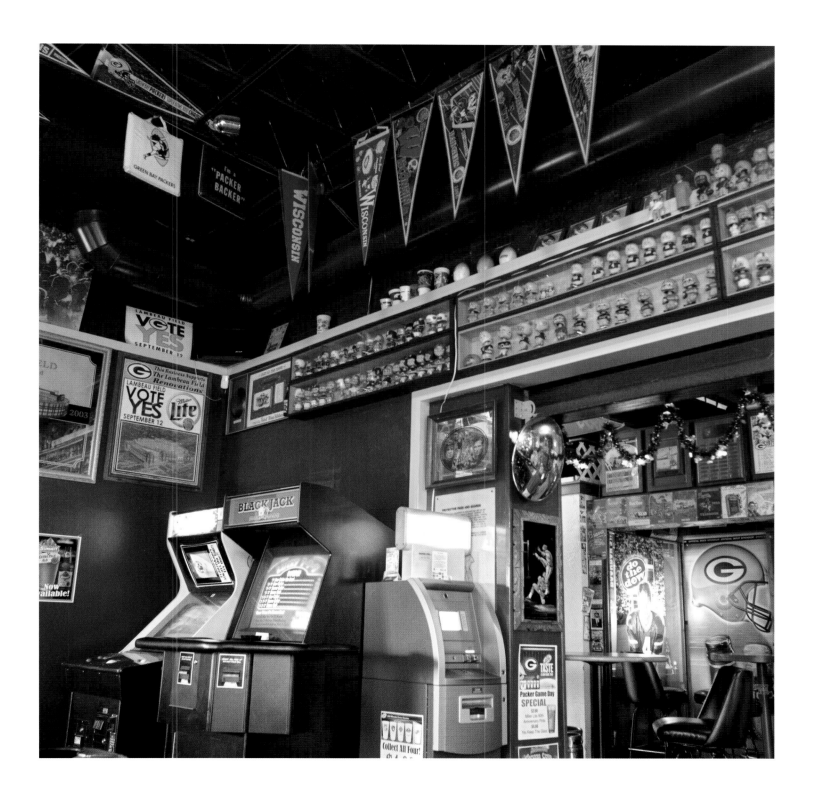

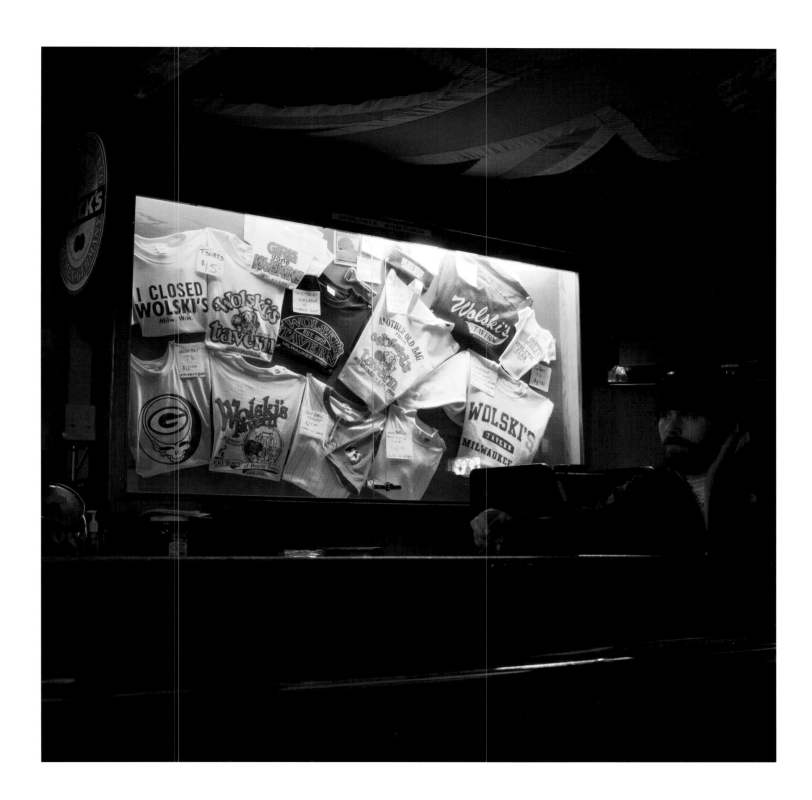

INDEX